INNER CHILD
HEALING

HEAL YOUR WOUNDS.

TRAIN YOUR MIND.

CREATE A NEW YOU.

WEN PEETES

REBEL FOR A SPELL PRESS
An imprint of Rebel For A Spell LLC
rebelpress@rebelforaspell.com
www.rebelforaspell.com

LIBRARY OF CONGRESS
CATALOGING-IN-PUBLICATION DATA

Wen Peetes
Inner Child Healing. Heal Your Wounds. Train Your Mind.
Create a New You.

Editor: Carmen Riot Smith
Cover Design: Steve Kuhn

Paperback ISBN: 979-8-9859630-0-7
Hardcopy ISBN: 979-8-9859630-1-4
eBook ISBN: 979-8-9859630-2-1
Audio ISBN: 979-8-9859630-3-8
First Edition, 2024

For childhood abuse and trauma survivors,
my sisters and brothers in hope and healing.
I love you. I see you. I feel you. I am with you.

CONTENTS

INTRODUCTION

You. Me. We.

My Dear Sisters and Brothers in Hope and Healing,

Wherever you are in the world, I long for you to have many moments of inner peace. I appreciate your grace and humbly accept these few moments we share as you read my spirit's offering to you. You see, you and me, we may be miles away, but we are seconds apart in each breath that receives our story, our truth, and our becoming the person we love so fiercely. Our lives depend on that love. You and me, we may not even recognize how purposeful we are.

We are doing the work of transforming barbed wire shackles into water!

Look how our resiliency nourishes this earth, inspiring and empowering our healing community and generations of girls and boys.

No, my sister, I'm not talking about ego or vanity; the perfectly shaped bum or breasts. No, my brother, I do not speak of the superficial ticket that may bring fleeting admiration from others; the eight pack or Ferrari. I am talking about all that makes us unique, our inside stuff.

Something happened to you and to me on our way to becoming an adult. Maybe it happened as we were discovering who we were in the world of grown-ups. Something put a full stop on the line where our childhood was blooming freely. No matter how we try, we cannot break our minds, bodies, and souls free of the "dirty." We feel the paralyzing darkness luring us into depression and anxiety. That's what the trauma givers and abusers would have us believe—that we need their trauma-transfusion, the rarest of blood, our connection to them, to stay alive. Well, NOT TODAY!

Do you know how remarkable you are, my sister, my brother? You! Yes you, right there breathing and reading these words. Right now, where you are in the room of your soul is where you *need* to be.

Some may see damaged. I see muscle building warrior.

Some see dirty. I see hard-working determination.

Some say shameful. I say wonderfully resilient.

Some say fallen. I say dream-reaching.

Some say weird. We say thank you! Unique is who we are! Authentically self-devoted!

Some say weak. We say sit down! Unclog your senses! Receive this lottery-prize lesson of an empowered human!

Do you know why I say all this, my sisters and brothers? We are always in motion through the devastating turmoil of childhood trauma. Our minds are constantly processing the trauma we endured, reaching back to pull that wounded little girl or boy forward into today and into a safe, supportive,

peaceful future. You, yes you. You are on that journey to your most authentic, confident, empowered, and self-loving Y. O. U.

You may not believe or feel that your life is where you need it to be. You may not feel like you have healed or you are healing. Yet, you are.

Please, I beg you, have mercy on yourself. You have suffered long and hard. Gift yourself that soothing grace. Hold space inside yourself—for yourself. Please put your hand to your heart. *Feel* the thread of life you are giving yourself so that you may deliver that breath, right there. That breath is a wonder, some call it a miracle. The little girl or boy inside of you is drawing *that breath* and gently becoming whole.

Breathing matters. You. Are. Doing. That. Bravo!! Please do not dismiss breathing as a nonevent.

As a woman and a black woman from a culture that dismisses the urgency of mental health care and suppresses a child's voice, I have struggled with the false perceptions that were "gifted" to me by the terrorists who abused me and by the culture that was complicit.

Raise your hand if this is you!

Yes. Yes! YES! We were set up! Our perceptions of who we are and should be, what love is and is not, our identity, what we need and what we do not need were set up by our abusers.

These wicked people showed us and brainwashed us with each and every terror they inflicted. They trained us to believe we were worthless and weak, and a vessel of hopelessness. These maggots taught us to believe that love and abuse must coexist

with every interaction. For some of us in our twenties, thirties, forties, fifties, sixties, seventies, eighties, in the years of our walk through life and even on our deathbed, we still believe the acid the abusers gave us was lemonade!

According to me, our abusers have been our biggest influencers. Not God! Not Buddha! Not Allah! Not Jehovah! Not nature! Not even Kim Kardashian!

Like you, I learned to brush my teeth as a child and now I do so on autopilot. As adults, often without thinking, we practice and reinforce certain abuse-programming on that same autopilot. The abuse is love, language, and mindset programming on repeat.

Here's an example I invite you to try. Please tell yourself the truth:

> How do you walk? Head hung low or high? Chest collapsed or lined up to the horizon? Back humped or straight spined? What is the first thought that comes to your mind when you think of yourself?
>
> When things don't go as planned, what is your first thought? How do you cope?

You and me, we were trained to believe if we were not being abused by someone or by even ourselves, then we would be without love. And yes, I will always tell the truth about my journey. I have abused myself with every harsh, hurtful action, thought, relationship, and behavior I participated in. I hurt myself. Why did I do this? Why was I so unkind to myself?

I mirror the earliest queues I learned as a baby and I carried them into adulthood. It is the language my parents taught me. It was the vocabulary I had and still use. Hurting and abusing was how I was trained to love. But not anymore!

My sisters and brothers, the *verb of love* feels safe, encourages you to express your hopes, soothes the fear and pain, and celebrates your dreams and your authentic self. Abuse is the complete opposite.

So many of us suffer in silence, without any support, with only our trauma wounds and shame for company. You are not alone. There is a community of supportive, empathetic sisterhood and brotherhood whose heart and hand you can depend on. I am part of that sisterhood, you are part of that support system, and many kind souls are too.

In this book, I share all my parts to keep Hope deep in our hearts and move onward into healing, together. In each chapter, I show you my why. I share my eternal healing journey from sexual abuse, physical abuse, and childhood trauma. Why do I share so candidly? This is how I disempower the wickedness that was put upon me. This is how I melt the barbed-wire shackles of shame and self-hate. This is how I create water that nourishes my dream life filled with self-love and inner peace.

Healing is a reality. Don't believe the whisper warrior full of negative talk inside your head. That bat faced life-sucker is a spy! It is an employee of your abuser.

Hope is the lifeline when everyone and everything around you says it is impossible. I am alive and writing this book because of Hope. You are alive, breathing and living as a result of Hope. I

believe you are reading this book because of Hope. Somewhere there is *always* Hope. Healing is believing in Hope.

Healing is refreshing. Healing is our possibilities and dreams made real. Healing is personal and self-divined. Healing is a practice, just like learning to walk. A crawl becomes a shaky-hold-on-to-something stand, becomes a wobble, becomes a step-then-tumble-then-stand-step-step, becomes a walk, a jog, a run, a leap then—there you are, in flight on the wings of your dreams.

My sisters and brothers, as long as you are breathing you are healing. YES! Small mercies lead to that flight of our dreams. Celebrate the wee little goodness you create and receive. These habits multiply unto themselves and create the example of your dreams.

Reframe the programming and the mindset. YOU are your biggest influencer! Not your abuser!

You are in control of when, how, where, why, and if you embark on your healing journey. Did you know you had that power?

Until healing became the destination of my next breath, I remained stuck inside my trauma wounds.

Healing takes grit. No one can make you heal. No one can heal you. You have to be ready to heal yourself, then do the work.

For me, healing is how I reclaim my life from the people who abused me and the wounds that worked to pound me into embers. Daily, I practice healing because it purifies my spirit, body, and mind. It unbreaks my heart. Healing keeps me in motion. It keeps me moving further away from the depression and the aloneness into inner peace and helping others discover their superpowers.

That's why, as I share my story in this book, I offer exercises and practices that are integral to my lifelong healing journey. I have included a "journey to self" section after each chapter that you may wish to try. I offer what I have learned along my healing journey. I share my habits of healing that keep me grounded in the Hope of touching the one dream that I have earned and manifested: my dream of inner peace and self-love.

No, we cannot undo the past. We use it as a ladder to keep reaching, believing, and living a love-powered and hope-powered life. We can live in service of our inner peace, our sisterhood and brotherhood of survivors, and become empowered by learning to create a reservoir of hope and healing habits. One breath and thought at a time, we tap into this safety, this reservoir whenever we need to, especially when life inevitably brings us challenges.

You. Me. We are the courage, the permission, the Hope, and the strength we seek and need. Let's go catch those dreams and soar on the wings we have created.

Thank you for trusting me with your time, energy, and Hope. Thank you so much for sharing your hopes and truth.

I love you. I see you. I feel you. I am with you.

Wen,
Your sister in hope and healing

1

What would happen if I tell?

What would happen if I were to tell? This question has lived with me for as long as I can remember. Until a few weeks ago, I did not know the answer.

But let's rewind a bit. In June 2020, I created the YouTube channel RebelForASpell. In the early days of RebelForASpell, I gave confidence, skincare, body care, and personal growth tips. I also gave self-love, natural hair, and financial advice. To my handful of followers, I encouraged them to step outside their comfort zones, to trust their decisions, and be the most authentic version of themselves. My followers and I were finding our way to ourselves. Back then, I felt that my rebirth was on its way in my bones. When? I did not know.

On November 20, 2021, while I was washing my coffee mug after breakfast, I dropped the sponge in the sink, rinsed the soap from my hands, and wiped them with a towel. I calmly walked into my bedroom closet and reached for a soft long sleeve, draped black and white blouse. I had bought it a few weeks before. I had planned to use it for a future video on my YouTube channel. I slowly walked to the bathroom mirror. I took a long deep breath from my lower belly.

I looked directly into my eyes and said out loud, "Wen, it is time. This moment is bigger than your fears of people knowing the truth about *why* you are."

An invisible, nurturing hand was guiding little Wen and me. Inside I felt calm. My mind, body, and spirit moved in unison. There was no self-doubt or debate. I had no explanations to give to anyone. No cat. No dog. Just a few tired-looking plants. The life of an introvert.

After putting on my makeup, I set up my video camera and studio lights in my home office. I walked in front of the camera and said the following.

"My name is Wen. From Shame to Celebration. I am ready to open up . . . to share . . . in hopes that it helps you or someone you may know. Because sharing is why we are here.

"At twenty-eight years old, me and God battled on a Virginia highway. I was done with living. The shame, the never-ending shame and self-hate was crushing me. Every single breath was a burden. I could not go on. Did not want to go on. Why? You see, my reflection, the face that is before you—the face that I see in every mirror—is the reflection of the monster, the killer who sexually abused me as a child. Every single breath was a burden. . . . Is this you? Is this you? Was this you? Is this someone that you know? Struggling. Every single day asking Why? Hiding from themselves?

"Like me, you may have heard these words or similar words:

She's lying.
Didn't happen.
Shhh. Don't talk about it. It will go away. It will get better.

You're crazy!

She's crazy!

Well, you know, she was always weird.

"You may have heard these words or similar words. I say to you. You, my precious loves. You, the survivors, the sufferers of sexual abuse, of trauma, of childhood trauma. You're trying to recover. But every day is a battle. I am with you! I was there! I am there! I will always be there! There is hope!

"You. You are the strength. We are the strength that we seek."

In that twelve-minute and fifty-five-second video, I permitted myself to be the most authentic version of Wen. I took the advice I had given my followers for the past eighteen months. With these words, I released myself from the last threads of shame with a clear mind and steely determination. I knew those words were the passage to total transformation. The truth that had once stifled me was set free. I had created a new version of myself. I was whole. I was free.

In creating that video "From Shame to Celebration Be the Truest You," my life's purpose was made crystal clear. I was meant to turn pain into purpose. A force far more significant than me compelled me to create that video. That same power put me before you, the reader of this book. I write this book to tell the truth and give hope. You, too, can find peace within your body, mind, spirit, and soul.

November 20th 2021, was my independence day. I took the wheel of my life and steered it in the direction of my purpose. I accepted all my parts. My list is long. Here's just a few. Fear.

Shame. Confusion. Depression. Wounds. Pain. Joy. Light. Resilience. Laughter. Curiosity. Peace. Purpose.

I hold no scientific or medical degrees. I have an undergraduate degree in accounting and an MBA in management. I am not an expert in psychology, physiology, or psychiatry. I barely liked high school biology. However, I am the authority of the constellation of my experiences. Good, bad, and horrible. I have survived and overcome the brutal suffering of childhood sexual abuse, physical abuse, mental abuse, emotional abuse, psychological abuse, and trauma. I was suffocated by fear, shame, and wounds that refused to heal for most of my life. I have already been at death's door many times. I have nothing to lose by sharing my story. You will find out as you read on.

Here are the facts that I know. My childhood was cut short. It had an expiration date. The date my father sexually abused me. According to me, that expiration date was day unknown, month unknown, in the year 1980. That is my first memory of being sexually abused by my father. But my inner child tells me the horror began years before. As I will say several times in this book, the body, mind, and spirit are connected. They tell the truth that we hide from ourselves. And those truths showed up uninvited, unwanted, and put me on my knees, wailing then running to escape the terror of little Wen's childhood.

And where was my mother in all this?

I have very few memories of my early childhood. Forgotten childhood years or periods, I have learned, are common in childhood abuse survivors. The wounds of childhood trauma

followed me into adulthood. Some people, even some family members, try to discredit adult survivors of childhood sexual abuse and trauma. Their behavior is a defense mechanism to get us to go quietly away. The topic is uncomfortable, and well, "Jeopardy!" will be on in five minutes.

This dismissal of our pain may not even be inflicted with malice or the intent to hurt. But my gosh, it does. It cuts you in half and makes you sink deeper into heartbreak, depression, anxiety, and confusion. All this makes the wounds bigger and bigger. They are feeding on us like leeches. Every breath becomes a burden. I learned through my experience that public perception of the family's good name must be preserved at all costs. But what is the cost of your mental health? Who decides the value of your life?

Please believe me when I say most people who disregard your suffering have wounds waiting to be healed. We are ruled by fear, avoidance, denial, and even overwhelming shame until we heal our inner child.

So many children across the globe have been abused or traumatized. Childhood sexual abuse is often a silent crime. Childhood trauma does not discriminate. Black. Brown. White. Gay. Transgender. Heterosexual. Rich. Poor. Educated. Tall. Short. Religious. Atheist. There are sick, wicked, and even protected monsters who are allowed to harm children again and again.

I am so sorry you have suffered. I am so sorry you still suffer. I am with you. I see you. I feel you. You may not feel it in this moment, but you are beautifully made—all parts of you.

I tell you my story without hesitation or reservation. Shame will not be my name! No more! Our will was taken from us at a tender age by those who abused and traumatized us. We, the survivors, control our destiny. We decide our path to healing. Not the sick pedophiles and guardians who confidently and systematically worked to break us down into tiny, manageable pieces. Not our family members who would prefer us to keep 'it' in the family.

When I was a child, it was and still is considered deeply disrespectful in my culture to tell your family business. To admit it to yourself was one thing. Something of great shame and surely a sin in somebody's bible. To admit it to your family? Well, that telling does not win you any awards of courage or bravery. Some family members do not even acknowledge that the story was told or their participation in the inheritance they received and have been passing on to their line—children, grandchildren, and on and on. It is far more polite to step over the puddle of pain than to fill it with healthy topsoil and plant a tree.

And to tell your family business to the planet Earth? What an abomination!

Ignore. Stay quiet. Smile. Pray. Jesus will take care of you.

So, when we are ready, you and I speak on behalf of our community who cannot speak for themselves! We fight for our brothers and sisters who couldn't fight for themselves. We fight for our brothers and sisters who are on their way to battle for themselves. We, the survivors of childhood sexual abuse and trauma, can transform pain into purpose. We can heal

our inner child wounds. I hope my story and other survivors' stories exemplify that peace can be yours too. You can become empowered. You can create a new version of yourself. You can become FREE.

Every person in my inner circle has suffered from some form of challenge that has tormented them since childhood. I was imprisoned by fear too. But no more! Our mental health needs attention. It is equally as important as our physical health. Our minds, body, soul, and spirit are interconnected. If one element is wounded, then all are affected. For our bodies tell the truth that our minds and spirits hide.

Do not let anyone shame you into believing that therapy is for crazy people. We listen, honor, and love ourselves enough to get all the healing we need. Brave? Yes we are! We are our heroes! We are our own parents. We had to mine the courage so that we could take each tiny step on our colossal, life-long healing journey.

I renamed myself. Who am I? I am self-love, courage, empowerment, and resilience. Who am I? I am gratitude and freedom. I healed the childhood wounds. I am on a path to purpose to help other survivors gain their independence from the bondage of shame and self-hate so that they may create new versions of themselves. I rebuke the generational inheritance of silence. I am in motion. From pain to purpose, from shame to celebration. I am living my life's mission.

We deserve the fundamental human right to feel whole. To feel safe inside our bodies, minds, and spirits. To be loved, most importantly, by ourselves.

You. Me. We are Empowered.

What would happen if I tell? I free myself from the bondage of shame and trauma. I heal my wounds and create a new version of myself.

You can too!

Journey to Self:

What we tell ourselves about ourselves has power. When the negative, harmful self-talk begins or gets overwhelming, this is what I do:

- I clap my hands as loudly as I can
- I say NO! Not now and not today!!
- I say I am in charge of this house! O. U. T!

What I have learned:

Healing requires motivation to do the work, day in and day out. We have to build the fire that pushes us to take out the boxing gloves and pummel the trauma programming inside us. Here's a sample of my motivation tactics:

- The less I have in common with my abusers, the better my life will be.
 - ☐ If I hate myself, we have something in common. They win!
 - ☐ If I disrespect myself, we have something in common. They win!
 - ☐ If I don't work to heal myself, they own my life.

I am the opposite of those wicked people. So, I lace-up, bob, weave, and believe that I. Will. Heal.

Habits that Help my Healing Journey:

My senses are healing receptors. What I see, hear, taste, touch, and feel can either harm or help my healing journey.

If my senses are overloaded and I am overwhelmed, I do not need to explain myself when I need quiet time. This is me, empowering myself to trust my intuition and take control of my peace.

2

Hello Truth

I was a strong-willed, defiant, and curious child. I asked too many questions when I was a girl. That's what my aunt Reedah said. My disposition was in direct conflict with my African Kittitian culture. My birth country is St. Kitts, an island in the West Indies. St. Kitts is part of a twin-island federation St. Kitts-Nevis. They are part of a chain of islands known as the Leeward Islands. From the air and on maps, St. Kitts looks like an acoustic guitar and Nevis looks like a guitar pick. Both islands are in the Northeastern Caribbean, not too far from Antigua and Barbuda, St. Maarten, St. Martin, and some more touristy islands. St. Kitts is bordered by the Atlantic Ocean and the Caribbean Sea. It has summer year-round, with a hurricane or four to keep us humble. St. Kitts' topography allows you to fête the views of the mountains, hills, lagoons, lush vegetation, and the warm lapping waters of the sea and the ocean. The abundant fruit trees made me curse every time I paid ten dollars for an avocado in New York, where I later migrated.

My parents never married. I lived with my mother in a tiny house in the capital city of Basseterre. Our house was less than

a quarter-mile from the Caribbean Sea. Mother came from a large family. She had eight sisters. One of her sisters died when she was a baby. Mother was twenty-one years old when I was born. Three years later, we moved from her family's home in a sparling village in the north of the island to Basseterre.

Mother was an independent woman. She was the first of her sisters to move out of the family home and rent a house. That was very unusual back in the 1970s. One was expected to be born and die in the family home, live on and off the family land, and follow the family plan. I was an only child for the first eleven years of my life. I do not have any memories of my father and mother being together as a couple. Mother did not speak about my father much when I was growing up. Neither did my father speak of her. I got the sense that they tolerated each other. Still to this day I do not know the history of their togetherness. Silence is of great value in my culture and in my family.

As an only child, I never felt lonely living with my mother in our tiny house in Basseterre. I had my dolls and my books. I loved reading and would borrow books from the library in a nearby village. I collected words I found in the books and put them in my black and white exercise book. From the books, I learned about strange places around the world. There was an island called Greenland that was covered in snow most of the year. What a strange name for a snow island! Then I learned about Elephants! In Africa! I found out that grown-up elephants were the size of three St. Kitts donkeys. Elephants became

my favorite animals. They liked water just like me. They were dark-skinned just like me.

I dreamt about playing with the elephants. Me and the elephants would go to the big rivers. I would stand under their trunks like a waterfall. The elephants would uncurl their trunks and I would dance and spin under the rain they made. I could not wait to play with them! The books also told me about volcanoes. St. Kitts had one volcano, but it was not working. It is called Mount Liamuiga. It stopped working not too long after the first people of St. Kitts, the Caribs, named it. At least that's what I heard as a child. I needed to see a WORKING volcano with lava bubbles, fluffy ashes, and giant rocky red-orange rivers racing for the sea. I dreamt of going to Hawaii because that's where the books said all the working volcanos lived. Until I was a grown-up and could go to those faraway places, my cousins and I went on our own adventures in St. Kitts.

I had eight cousins at the time. The largest age gap was about twelve years. Some of us were born in the same year. I was one of the youngest. Most of my cousins lived with my maternal grandmother in the family house, on the family property, in the village that me and mother moved from. I would go to granny's house almost every weekend and stay with her and my cousins. We were free to be children. Granny encouraged us to express ourselves. She listened to us, not just our words. She gave me and my cousins her full attention. Granny played with us. The entire village loved granny. Not just me and my cousins and my family, but everyone. Granny fed the neighbors from her little

almost-farm and baked extra pies and bread, because someone needed a meal, somewhere.

There were two boys and six girls in our little cousin community. We would put on talent shows and find different ways to entertain ourselves and granny, whom we adored. We pulled vines and weeds that bothered granny's mango, soursop, papaya (known locally as puupooy), sugar-apple, and pumpkin trees. We plaited the vines into ropes and used them to skip. My cousins and I took turns skipping. When we were bored with that, we played hopscotch in the dusty patch of dirt near the tall guinep tree. We chased granny's pigs and played tricks on granny all weekend long. We created homemade radios. We caught bees in glass jars and covered the jars with metal caps. We had punched holes in the caps using rusty nails and big smooth stones that we found in granny's big backyard. We pressed the metal caps to our ears and listened to the bees singing and buzzing until we set them free and replaced them with less tired bees.

On Sundays after attending the mandatory church service and Sunday school, we would be free to roam the nearby hills while granny made lunch and her famous coconut tart. We'd march up the track at the back of the house. We went through the empty cane field and over the hill. My eldest cousin, Jason, was the leader of the pack. Our youngest aunt Avril would tag along with us sometimes. She is three or four years older than Jason. We hunted for wild birds. Jason would kill them with his sling made of wood and rubber band. We plucked the feathers, rinsed the naked birds with water, and laid them next

to unpeeled sweet potatoes. Together, they sizzled on granny's coal pot, roasting over burnt orange coals. It was delicious! We created our own little village. We loved each other. We were each other's friends and protectors. But there was much about my home life I didn't share with my cousins back then. Silence was the family heirloom.

A child always kept a child's place in that once British colony of St. Kitts. The parents were to be respected. Always. As children, we feared our parents. Parents were the Gods of the house. They were the Gods of our lives. They governed our behavior and policed our thoughts. At least that's how it seemed to me and my best friend Julie. Parents could read our minds and punish us even before we did the thing for which we should be punished. Fear was reinforced with severe training. Good children obeyed. Always.

Even when you became an adult, your mother was called Mummy in my culture. Your father was called Daddy. Your parents' needs came before the needs of all others. Your needs. Your friends' needs. If you were to get married one day, your parents' needs came before your spouse's needs. Your parents' needs came before your children's needs and their children's needs.

Remember what I mentioned earlier—your parents were in charge of your world. Mother was smart and physically beautiful. She had a natural warmth that made everyone feel comfortable. People felt like they could be themselves around her. Every meal she prepared tasted like the best meal I ever had or wanted to eat.

So much flavor. So delicious. Mother was known for her salt-fish, the national dish of my island. She still is to this day. Everyone seemed to love her. People would see her and call her name as if they were singing a song. JoooOOooY! Our little house was always full of passerbys, sharing vegetables from their farms or freshly caught fish. Whatever they had they would share, and mother would share whatever she had. Mother has the type of laughter that would make you laugh all day, not having a clue why you were so happy. On your drive or bus ride home, you would still be laughing, then you would remember why and think to yourself, Joyous, Joy.

I have vivid memories of being beaten by my mother when I was a child. This was her communication style when she was angry or vexed. Mother was loving and strict. She was kind to me mostly, but she would become this raging wild thing on whipping days. Every few months, I got a proper lashing for one reason or another. Some whippings were more violent than others. I tried to escape by running to different rooms in our seven hundred square foot home. It was useless. She followed me. The traveling-beatings continued. Wherever the blows landed, they landed. They stung like hot coals. Mummy would continue whipping and lashing me until she was too tired to hold her hand upright. Tears, screams, and hollering came from me. Sweat and grunts came from her, while she said, repeatedly:

You can't hear. You must stop (Whap)
You must learn to (Whap, WHAP, WHAP)

Those were words and sounds I heard while my mother was beating me. I still hear them. I felt a quick hot breeze just before the lash found its spot if I was near to mother, as she lifted her hand to make the swing. The traveling whippings continued. I was hopping, springing, ducking, diving, and wailing from the lashes while trying to cool the last "burn spot." Mother was storming, swinging, shouting, and pouncing. The neighbors heard, for the houses were less than six feet apart. There was no rescue. Some, not all mothers were doling out the same punishment to their children. This was how you mothered.

Back then, I knew my mother to be a fair person. So, I probably disobeyed in some way and deserved to be punished. The whippings felt like a one-sided war. Why was I being disobedient? Was I acting out in some way? I cannot imagine why little Wen would ever keep subjecting herself to that known brutality.

Were the beatings the proper punishment for whatever it was that I had done?

Mummy was a physically strong young woman. She was five feet nine inches and at least one hundred and sixty pounds. I was no more than fifty pounds and under four feet. Whatever caught her grip, a belt buckle, pot spoon, a shoe or broomstick, it found my body. My skin tore, but mummy's 'training' persisted. I collected many scars, especially on my legs and backside. I got some of these scars from being a tom-boy, mosquito bites, falls, and scrapes that come with being a child. Others, the big ones, came from the whippings. Some of the scars looked like

the nearby islands. I was fascinated by geography back then and I remembered thinking:

This one looks like Anguilla. This one is like Montserrat. This one is Nevis.

Growing up, I was a scraggly-looking dark-skin girl. My eyes were the size of dessert plates. My hair looked like an open black umbrella made of wool and my body looked like twigs attached to a broomstick. At least that's what I thought. Most of my family members looked like that from the few pictures I had seen. I had many nicknames. Nappy Head. Picky Head. Big Eye Barkable. Ping Pong Foot. The one that hurt the most was Spottycolonious. My 'friend' and her sister who lived next door gave me that name in honor of the spots that littered my thighs, calves, knees, ankles, and shins.

The bullying and scarring affected my self-esteem. Although I could avoid seeing my next-door friend, I could not get rid of my scars. I have some of these scars still. Severe hyperpigmentation is a condition that runs in my family. Our spots take double-digit years to fade. Some of the spots do not disappear at all. This condition skipped my mother and some of her sisters. None of my cousins or my brother grew up with this severe hyperpigmentation. Their cuts and bruises healed, and their scars faded, sometimes without applying cocoa butter or fade cream.

While I was being punished so harshly by my mother, I felt she hated me. At different points in my childhood, I thought that I was in the way of someone's life, her life. I felt like a burden.

It is difficult for me to admit this, but this is my truth. Later, I learned that the punishment and treatment I was receiving from my mother was the family inheritance.

As a child, my mother learned to suffer in silence and endure the whippings she had received. It was customary for some parents to communicate with silence or whippings. This was the family inheritance, from mummy's father and his mother to him. I can't speak for my father's parents. I never met them. He didn't speak about them.

My family, my neighbors, and many of my friends were whipped by their parents in this way. It was normal. This kind of punishment was the natural order of things. Parents were the Gods. The common understanding for many children back then was that if your parents were upset with you, they would answer in one-word sentences or silence. These were the burning red lights. They said stop. Go no further. Trespass, and you will get burnt. It was unwise to ask or guess what was upsetting your parents. The safest thing to do was to avoid your parents during these episodes. Go. Diminish yourself into the farthest corner of your bedroom and stay. Quietly. Until something lifted your parents' mood. Or if a visitor came by, that was a blessing. You could then come out from hiding and maybe then be a child again.

I love my mother. I forgave her years ago for the brutal whippings. She did the best she could with the little she had. Mother came from a poor family. She was the first of her sisters to get her own apartment and be financially independent of her parents. Mother loved and cared for me as best she could. I

never went hungry. I had all the toys I needed. She encouraged my love for the piano, writing music, singing, studying dance and French, and performing. She taught me how to cook. My mother taught me the importance of proper hygiene and made sure I was physically healthy. She taught me to believe in myself. She stood up for my brother and me when we were being bullied in school. Mother taught me to work hard to achieve my dreams. She took me on my first plane trip. As an adult, we had many fun adventures traveling together around the world. Mother is a wise woman whom many people seek for life advice. Mother is one of the kindest and funniest people I know. I am grateful for her.

As a little girl, my mother was not my hero. Everyone who knew my family and me knew who my hero was. My hero was the person who rescued me from the brutal whippings my mother gave me. My hero was my father. Back then, he was a man of some prominence in my country. He was in the army and was quickly moving up in ranks. He lived less than one mile away from my mother's house. I preferred spending time with him. We were twins, at least that's how I thought of us. Although I am dark-skinned and he is light-skinned, there is no mistaking that he is my father. Throughout my life, people of my country would greet me by saying, "Girl, you look just like you father, eh?' or "Norman daughter. How you doin?"

I knew very little about my father's family. He said he grew up in a children's home. It was like an orphanage. I never met his parents. I don't know what happened to them. He never

spoke about them. I always thought they had died. I don't think I asked him where my grandparents were. A child kept a child's place in my culture. My father had four siblings that I knew of and met. He had a grandmother, three nieces and two nephews that I knew of. My father had four other children, including a son who he did not acknowledge as his own, Brian. Brian was my youngest brother on my father's side. As a child, through my mother, I grew close to Brian. I love him dearly.

My father took me to visit my great-grandmother several times. I never knew her name. She was just granny. My great grandmother was a small, thin old woman with a ready smile. She had curly hair like a doll's hair. She lived in a tiny wooden house not too far from the orphanage where my father grew up. Physically, my new granny was different in many ways from my other granny, my mother's mother. I did not know my new granny very well. I don't know where she was born, who her parents were, or even what she liked to do. But I liked my new granny. She made me laugh a lot. I remember she would look directly at me whenever she spoke to me, like she was genuinely listening to me, just like my other granny did. New granny had a soft voice that reminded me of how my pillow felt under my head. New granny would ask me how I was doing. She asked me about school and my friends. Every time I visited new granny, she would say, "You look just like you father, eh!"

Then all three of us, my father, new granny, and me, would laugh at the same time. Granny died after my fifth or sixth visit to her house. I still do not know new granny's name.

Throughout my childhood and especially during my high school years I felt my father and I had a special bond. One moment stands out. One afternoon, during my senior year in high school, mother and I had a knock down, dragged-out argument. I had to get away from her. I had to get away from that house. I went for a drive with no destination in mind. St. Kitts is only sixty-four square miles. There were not many places to escape to. Plus, everyone knew everyone. You had zero privacy. Anonymity was impossible. I ended up at a small beach on the southern tip of the island. This was my favorite beach. It was the beach where my father taught me how to swim. I sat on the warm sand with my back to the hills and my face to the Atlantic Ocean. I eased out of my flip flops and dug my toes in the inviting sand. I hugged my knees and my head at the curve of the embrace. I tried to calm the chaos inside of my mind.

I don't know how long I sat there, but I remember feeling hopeless and confused by the continuous demise of my relationship with my mother. Our relationship was complex, frustrating, and dysfunctional. Our communication was soon to be nonexistent, I would find out a few weeks later.

On the beach, I stared at the ocean without really appreciating the beauty in front of me. When I raised my head, the sun had started to set. As I watched the wind surfing the top of the ocean, I said to myself, "I wish Daddy was here."

I turned my head toward the sea grape trees that fenced the beach, dividing the beach from the narrow unpaved road as I said these words. I saw father. There he was strolling toward me.

It was surreal, but not a surprise. We had a close bond. He was my hero, and he was doing what heroes do. He was coming to my rescue. I sighed in relief as I watched him walk toward me. As we looked at each other, we both gave a brief nod. It was an unspoken understanding of what I had been enduring with my mother. He acknowledged my wish not to discuss the events of the day just yet. My father sat on the sand next to me without a word.

Sitting there with my father, I felt my hero had arrived on time and brought what I needed most. I needed to feel safe. I needed to feel like I belonged. I had both. With his silence he listened to me. We watched the ocean and the passing boats together. We watched the sun complete its journey. We left the beach and talked over dinner about what was happening with mother.

My father remained my hero, until *that* episode of The Oprah Winfrey Show.

I left St. Kitts about two years after completing high school. I went to New York to go to college. Some of my aunts and cousins were living there. New York was a familiar city. I had traveled there many times to visit my extended family when I was a child. After graduation, I soon landed my dream job with a large international firm. I was grateful to find a good-paying job that allowed me to support myself and send money back home to my mother.

When I moved to New York, I could not get a good night's sleep for some reason. I used to sleep for eight hours straight

when I lived in St. Kitts. In New York, the most I slept was two or three hours before waking up from the same recurring dream. I was running outside. I was running fast. My heart was pounding in my ear. It was determined to leap out and run ahead without me because my pace was too slow. Something was chasing me. I wore a plaid dress with elastic at the sleeves that flared like a skirt, halfway down my upper arm. As I ran, I kept looking over my shoulder. I was petrified. I was barefooted.

I remember the blackness of the night and the moon I used for street lamps. Except there was no street. I was running among trees and bushes. Some of my afro-textured hair was braided. Some of my hair was open, loose, and fattening in the night wind. As I turned my head to look behind me for the umpteenth time, I could see a shadow of not a thing, but a human form turning the bend in a sprinting frenzy toward me. My eyes were unblinking and wide with terror as I watched the road between us get shorter and shorter. Panting, I woke up with a start. One arm was in front of me at a forty-degree angle, like I was cutting the air, running. I was sweating, terrified, and disoriented. I never understood that dream back then. I still don't.

I enjoyed living in New York. I liked my job. I met one of my dearest friends at the firm where we worked. There was something called busy season at the firm. For the first four months after December, we worked sixteen to eighteen hours, six days per week to meet specific deadlines. Finally, April came. I was ready for a vacation. It was a relief to get away from the sounds and smells of Manhattan. I would not miss the mosh pit

on the trains. During rush hour, people were usually pushing and shoving to get everywhere. Some subway riders were smelly and heavy with flatulence that always seemed to stall at the tip of my nose. I would not miss *not* getting a seat on the sardine can trains, having to stand and rock for over an hour, concentrating on grabbing my purse with one hand while holding the rails with the other. I would not miss always remembering not to look people in the eye. I would not miss having to remember not to fall asleep, lest I end up in Brooklyn. It took me three hours to get home that one day I fell asleep.

During the few days of my stay-vacation I tried to rest my exhausted body and mind. The running dream returned. I had long since accepted the frustration of not being able to sleep for more than a few hours at a time. I knew a lot of people who suffered from insomnia. I didn't think much of it. I didn't tell anyone about these dreams. I was an introvert. I lived alone. I was single at the time and was glad to not have to 'deal' with anyone. To occupy myself on my staycation, I cleaned the apartment, went running around the neighborhood, did the laundry, read, and watched television.

Either a Wednesday or Thursday afternoon during the first week of my staycation, I was sitting on my bed and folding laundry, absentmindedly flipping channels. I stumbled on The Oprah Winfrey Show. A white middle-aged woman was trying to tell Oprah something. It was hard to make out what the woman was saying because she kept crying and wiping her nose. The woman was in anguish. At one point she stopped speaking all

together. I saw Oprah rest her palm on the back of the woman's hand, as if trying to calm the lady. The woman began to speak again. I cannot tell you exactly what the woman told Oprah. This is what I heard.

> Woman: "We were . . . he said . . ."
> Oprah: "Your father?"
> Woman: "Yes. He made me . . ."

Like a sinkhole swallowing a car, Oprah and the woman disappeared from in front of me. Immediately, I saw a girl sitting on a brown sofa in a living room. She was sitting near the front door. The door was painted a blue-green mint color. It had two halves. The right half of the door had a brass knob. The girl was wearing a dress. The girl was not alone in the room. Someone was with her, sitting on a chair facing the door. They were watching television. Then I saw the girl get up from the sofa. She was following someone. A man. The girl was walking behind the man, out of the room with the television and into another room. They were not speaking. There was a window directly ahead. A brown bookshelf was against the left wall. There were magazines on it. A small bed was pushed against a wooden wall. A dresser stood not too far from the foot of the bed. The man sat at the end of the bed, near the dresser, then he pulled himself up to the center of the bed. He patted the bed. Pat. Pat. The girl sat on the left side of the bed. The man said something that I could not hear, then the man spoke again.

The voice said: Let's play wrestle.

Those words hit me like a gut punch. That voice! I knew that voice. The scene before me screeched in my mind. I shook my head as if to swat away the scene and take me back to folding the laundry. I shook my head again and again. I thought, take me back, please. Please take me back to my apartment. The onslaught of scenes before me were punching my lungs and stabbing my heart. I knew what was happening because I *felt* what was happening to that little girl, in that room and on that bed. I knew what that monster was going to do to that girl.

NOOOOOOO! I screamed.

I sprung from my Murphy bed in my apartment. I was jumping. I kept trying to jump out of the movie. Trying to get away from what I saw him doing to the little girl. I was wailing, jumping, crying and screaming. I was trying to make the movie stop. I felt like I was losing my mind. I could taste sour bile in my mouth. I was shaking and started to retch. I was retching and heaving, but there was nothing in my stomach. I kept retching. My head was spinning. I saw the man pulling the girl's wrist. The girl was looking down at his wrist on the bed. The man was telling her something, coaxing her. The girl looked up at the man. I saw his face. It was my father.

I must have passed out. I was laying on the floor. My face was pressed against the carpet. It was dark outside. I didn't know it then, but I had a flashback. It was a flashback of my father sexually abusing me. The repressed memory had returned to

me. I was numb. I was devastated, appalled, and in too much pain to move. I cried and cried in shame. Long after the sun went down, I was still crying. The origin of my life was being dismantled. What do people say? A girl's first love is her father. In my case, my father, my guardian, was also my killer. The day Oprah opened the memories of being sexually abused by my one-time hero was the worst day of my life. Still.

That day I felt disemboweled, mind, body, and soul. How could MY father have done this? My hero did this? No. NO, NO, NO! How could my best friend and mentor take advantage of a child? This was madness! I felt I was losing my mind. My mind was at war with itself. I was lost, confused, heartbroken, terrified, ashamed, and alone. These memories terrorized every cell in my body. I was a living nightmare; except I was wide awake. I was in my apartment in New York, utterly emptied of feelings. I couldn't figure out how to get off the carpet.

My mind and my body kept me planted on the commercial-grade carpet. I hardly moved while lying there. My body was not cooperating. I wanted to get up, but I couldn't move. I tried moving my toes. They were working and so were my fingers. It didn't look like I had a stroke or heart attack. I was breathing steadily. I needed to get up, to get some pain killers. I needed to quiet the big band in my head. Every time I blinked, it felt like gravel was in my eyes. Crushed tears had settled in the corners of my eyes. I stayed there on the carpet into the next day. It felt like I was lying on a concrete slab. My right side was numb, but I couldn't figure out how to get off the carpet. I

heard the school children get off the bus. I heard my neighbors come in after work.

I remained on the carpet looking at its thin weaves, picking at its fibers. I felt like I was waiting for something. I did not know what. The late-night bus schedule kicked in and the street noise quieted. Slowly, I started to feel, well, different. It is hard to explain. Something new was happening to me. I was still on the floor, but it felt like someone had cracked a window open ever so slightly.

There was a flitter of something, something inside of me. I did not hear anything or see anything, but I knew I had to get up. I had to get going, to take care of something urgent. I did not know it then, but I was connecting with my intuitive self. My intuition told me to get up off that carpet, brush my teeth, and take a shower. So, I did. I was ready. I was ready to be a little less dead.

Not too long after *that* Oprah Winfrey Show episode, Mother visited me in New York. Through tears, sobs, and halted words, I told my mother that my father sexually abused me when I was a child. I do not remember my exact words. My cousin Heather, who was there with me for support, may have even filled gaps in the sentences I couldn't complete. I had told Heather a few weeks prior to mother's visit. Mother was sitting on a stool in the kitchen of my studio apartment in New York. I remember her reaction like it was today. My mother's response was like Heather's reaction except more intense. Mother leapt out of her chair, raised both her hands in the air, palms facing out, and

she said, "WhaaaAAAAAAAAAAAAAAAAa! WHAT?!! What are you telling me?! What is this you telling me, Wen?"

Mother kept repeating these words as she looked back and forth at me and Heather. Back and Forth. Pacing in the tiny kitchen, she kept asking, "He?! Did?! What?! WHAT!!!"

To say she was shocked is an understatement. She was disgusted. She was wounded. She was crying. Heather was crying. I was bawling, shaking, ringing my hands, and unable to look at mother any longer. I was ashamed. Mother never knew about the abuse until I told her.

I told my mother about my repressed memories and how they had returned to me. I began to tell my mother about one of the episodes of being sexually abused by my father. About the third sentence in, the shame and self-hate I felt was too much to bear. I was ashamed that I had 'allowed' myself to be abused by my father when I was a child. I was ashamed that I had forgotten my father abused me. I was ashamed that I had hurt my mother by telling her my father had sexually abused me.

In that moment, when I was speaking to my mother, I was berating myself with negative self-talk. The air was becoming tight. It was getting too hot in that tiny kitchen. I had to get out of there! I ran out of my apartment, bawling. I was in agony. I was falling apart. Even as I write these words, I am overwhelmed with grief. I am transported back to my kitchen with the three beige walls, lemon decorated curtains, dinner table from my auntie Ket, the green and silver linoleum floors, and the four

oak cabinets. I can hear the humming fridge. On that day the humming sounded like helicopter blades.

The remainder of mother's visit was filled with many conversations, long silences, tears, and heartache. I felt mother and I grew emotionally closer that summer. Well, as close as we could be in that moment. I had opened up and trusted her with my darkest secret. I don't remember us hugging. Back then, I did not like to be touched. I do not know what I needed from my mother that day. In retrospect, I think I just needed to be heard, for her to listen, truly listen to me. I needed my mother to believe me. I felt she did.

Insomnia completely took over my life after that July and continued long after mother left for St. Kitts. I would sleep for an hour or two, then be awoken by nightmares. My physiology changed, my body, mind, and spirit. Every breath felt like it was a burden. I did not feel good about myself. I did not like myself. I was tired. Always. Exhausted. I pretended to be happy at work and interacted with my co-workers. But the charade of a successful career woman was too hard to keep up. The forever sadness, hopelessness, shame, nightmares, and self-hate was sucking me dry. I was spiraling into depression.

It wasn't until I began writing this book that the scope of my childhood trauma fully registered. While my mother was beating me, I was being sexually abused by my father. This truth swept me up like a tornado. I was spinning in a funnel of a new reality. There was no real home or safe space. It took me several hours to recover from this realization. I grieved for that

wounded girl. Who was my guardian and protector? It was not my mother. It was not my father.

I see my lost memory as a form of mercy. My brain protected me until I was physically away from my parents. My brain locked those memories far enough away until I was more physically, emotionally, and spiritually mature. The memories of being sexually abused by my father were wreaking havoc on my life.

At this stage of my suffering journey, I was learning a lot about myself, unbeknownst to me. I was learning my *whys*. I did not know it at the time, but this period of truth-discovery was the foundation of my healing journey.

Let's explore our truths by trying the "Journey to Self" discovery exercise I have included below. Empower yourself to ask the questions, reflect, and provide the answers. Please try to respond without punishing yourself or judging yourself. Empower yourself to set the pace of this exercise. You are in control. If you wish to take one question at a time, you may do so. If the revelations are too intense, step away from the exercise and let fresh air into your spirit. Remember, you are in control. Trust your decisions.

Journey to Self:

1. What do children need from their parents?
2. What do adult children need from their parents?
3. What do adults need from themselves?
4. Did you experience childhood trauma or childhood abuse?
5. Were your memories affected?
6. Does it sometimes feel like you have to get away from yourself?
7. Does it feel like somehow everyone knows your big secret of being abused or traumatized?
8. Do you blame yourself for your suffering?
9. Do you believe you can transform the pain?
10. What is the one big problem you need to overcome?

Looking inside our history of childhood abuse and trauma is extremely difficult and can take many years. We sometimes ignore

and push down the truth out of fear. We don't want that raw pain to return and interrupt our lives. The truth is, the shame and pain are already disrupting our lives and sinking into our subconscious. That fear strengthens and makes it harder for us to find our way out to ourselves. I see you. I feel you. I am with you. I believe we have the power to give ourselves what we never received from our parents or others. I believe we are the great courage we seek.

I have learned many things at different stages of my healing journey, some of which I share with you. As you read my offering, please consider what you have learned along your path to your now. You may be surprised to learn how mighty your mental stamina has become.

What I have learned:

1. When you claim your truth, no one can hold your dreams hostage.
2. The truth cannot be suppressed.
3. The truth always finds its way to the surface.
4. Childhood sexual abusers will work to discredit the survivors' truth.
5. Your truth, your life, your pain, your joy cannot be discredited.
6. Sometimes no one will want to listen to you or believe you.
7. Listen to your body, mind, and spirit. This is your collective intuition.

8. Learn to trust your intuition. We were all gifted with it since we were children.

9. We are often ruled by fear and taught to respect fear.

10. We are seldom taught to respect our truth and our intuition.

11. You do not need permission to tell your truth to yourself.

12. Someone else has experienced some aspect of your suffering. You are not alone in the struggle for inner peace.

13. Discover your tribe, your community of belonging.

14. When you are ready to acknowledge your truth, you will know.

15. There is no healing race. There is no stopwatch. You set the pace for your mental, physical, and emotional transformation.

16. Your healing journey is unique to your life experiences.

We, the survivors of childhood abuse and trauma, are the experts in the battle to save ourselves. We are the authority of the constellation of our life experiences. When we tell ourselves our truth, we honor our life history. In unraveling my past I found courage. I found the strength to tell my mother what my father did to me.

I had found an unseen nook inside myself. Although I could not see it, I felt it. That nook was my intuition. There are many definitions and spiritual explanations associated with the word intuition. We were all born with an inner voice that warns and protects us. Being abused affected the connection I had to my spirit and my intuition. When I saw, heard, and felt my truth, I began to hear my own voice. I trusted my intuition to take

me through the worst day of my life. My intuition was leading me on a path that I never could have predicted.

When we honor our truth, we allow ourselves to visit the power that we may not know we were capable of summoning. Yes, I said power, because it takes tremendous power, mental stamina, emotional maturity, and courage to sieve through our souls and uncover our whys. You have that power within you. Please remember to have mercy on yourself. You and no one else set the pace for your healing. Remember to give yourself some grace.

My habits to healing are my "superpower juice." They may take as little as five seconds or as long as my lifetime. These habits are the micro thoughts, words, and actions that I do every day to keep on my healing track. Spend a moment or two to consider your healing habits and try to incorporate them into your day.

Habits that Help my Healing Journey:

- Telling myself the whole truth, even if it hurts.
- Creating and *feeling* affirmations and saying them out loud. I created this affirmation to help myself in my healing journey:

In gratitude of a new day, I rise to self-compassion. I rise to self-love. I rise to purpose. I rise to Freedom.

3

Picture of My Face

What do you do when your existence terrorizes you? My face is identical to the person who sexually abused me. As a child, my father was my favorite human being. I followed him everywhere I could. He taught me how to swim. He taught me how to dive. He taught me how to float above water. He instilled the value of an education. He paid for my tutoring sessions. He taught me how to drive. He taught me how to change a flat tire. He taught me how to wash a car. Wherever we went people would greet him with respect. Everyone seemed to know his name somehow. He rescued me from the brutal beatings my mother gave me. He was my hero. He was responsible for my birth. He was responsible for my safety. My one-time hero was almost responsible for my almost death.

My reflection traumatized me. For a long time I could not look at my entire face in the mirror in one viewing. I trained myself to focus on parts of my face. Having my full features in view would sink me into depression. Being an extreme introvert at the time and living alone, it was easy for my decline to go unnoticed. But it wasn't enough. I saw the man who sexually

abused me everywhere. I saw the man who abused me in the things that I once enjoyed. He was there. In water. In cars. In reading. I would see a word and remember how he taught me to spell it. Just that would send me into depression. How could I escape the cellular level of this war? That's what it felt like. I was fighting and I was losing the will to remain connected to myself, the person I hated most.

I hated the sight of myself. I was disgusted. I could not run away from myself. I had his face. My widow's peak was his, stamped in the center of my forehead. His. I shaved it. It grew back. No escape. My eyebrows. That Himalaya peak on the right brow. His. My eyelashes, thin and wispy. His. The shape and color of my eyes. My up-turned nose with the too-high nostrils. His. My round lollipop face. His. My too-big eyes. His. My crooked mouth. His. The only thing I have from my mother is my chin. Every time I saw myself, or parts of myself, I saw that pedophile's grotesque face. When my eyes were open or when my eyes were closed. The demon was there. What a haunting! Night and day.

The nightmares were playing inside my head on automatic repeat. I call them nightmares, but I did not need to be asleep to experience them. The reel of being abused would start playing randomly in front of the person or thing I was looking at. As clearly as I am typing these words, I can see the horror of those two memories I have of being sexually abused. I was being retraumatized. Was this to last for my entire lifetime?

Every day, I was witnessing myself being retraumatized by my childhood abuse. Specifically, being sexually abused and betrayed

by my father. My life had been split into three divisions. The first division was the little Wen I knew before I remembered being sexually abused by my father. The second division was the little Wen that existed after I remembered being sexually abused by my father. The third Wen is the adult Wen. The adult Wen is the caretaker of all three divisions.

I felt more like the warder of the three divisions. I did not know who I was. I did not know *what* I was. Sure, I was living, breathing, and eating. But I was completely empty inside. Thoughts of suicide plagued me. That was the promise of relief. I desperately needed relief. I kept telling myself. I had nowhere else to turn. My mother was back in St. Kitts, and my father was dead to me. Strangely, part of me did not want to hurt my mother. I believed she would be hurt if I were to end my life.

My relationship with my father ended in 2002. Remember that summer I ran out of my New York apartment after telling mother what my father had done to me? I eventually returned later that day. From the front door of my apartment, you had an entire view of the place. The loft style living room and bedroom were to the left of the front door. The Murphy bed sat in the middle of two closets. The bed and the closets ran parallel to the kitchen and the bathroom. As I opened the door, I saw mother. She was still sitting on the kitchen stool, under the lemon curtains. My mother's head had fallen onto her shoulders. Her already tiny eyes were like lines drawn in the swelling around her eyes. Mother had aged at least fifteen years since I spoke to her two hours before.

I gave my mother a letter to give to my father when she returned to St. Kitts. That's where they both lived. My father lived with his wife. My mother lived with my little brother. I had typed the letter a few months before mother visited me in New York. I typed the letter on my word-perfect machine I used in undergrad to write my papers. The machine was a cross between a typewriter and a personal computer.

Remember that day I told you about? That day I couldn't figure out how to get off the carpet? Well, I got up off the carpet. A force pulled me up and gave me the task of writing a letter to my father. I had to write that letter right there and then. I took my word-perfect machine from under the dining table auntie Ket gave me. I sat under the lemon curtains right where my mother would sit four months later, and I typed.

There were many stops and starts. I fought through tears to type that letter. I pushed the tears away with a paper towel and typed with trembling fingers. I could not get up to get a tissue. There was no time for that. I was not to leave that dining room chair for fear I would not finish that letter. And damn it! I WAS going to finish that letter.

The shame never left my side as I wrote that ten-page letter. I put that shame on the windowsill, and I poured all my disgust, anger, hate, and feelings of betrayal into that letter. I was angry as all hell. I was thumbing those keys, crying and cussing out loud over the sound of the word-perfect machine. I would type entire paragraphs without shedding a tear, then out of nowhere I would start bawling. I would type two words, then start crying

again, pausing to wipe my nose and eyes. I got the hiccups but did not move from the dining room chair. I HAD to finish that letter. I came out swinging with the opening sentence.

You are a sick, nasty, horrible, piece of s___, wicked child molester. You should burn alive. How could you do this? How could you do this to me?

I told him his secret was out, the one he thought I would not remember. I told him how much I hated him. I told him how I remembered the play wrestling and that I knew he molested me many times. I denounced him as my father. I had no father.

My mother gave my father the letter. She said he denied sexually abusing me. He said I was making up stories about him. I was not surprised. That was his defense. I mean, he had to tell his wife something when I stopped calling and writing to them. When I graduated college, my father had offered to help me pay my loan "until I got on my feet." I had a federal student loan from the St. Kitts government. I was paying eighty percent of the loan. My father was paying the remaining twenty percent. The month after my father received my letter, he stopped helping to pay my student loan. Were these the actions of an innocent man? I had cut him out of my life. I confronted him about his wickedness and his sickness. He could keep his money, along with the truth he had to swallow. He was not my father. I had no father. The day I wrote the letter to my father, I redefined myself. I went from daughter to fighter. The fighting had just begun.

My childhood trauma was going to be the death of me. I was stressed out. Feeling stressed is a normal human reaction to everyday challenges and changes that we all experience. Most people have short-term stress. Feeling physical, mental, and emotional chronic stress was my load. Since the spring when my repressed memories upended my life, I felt like this. My energy to do all the things that I once loved was gone.

There was no Nina Simone, Nas, Rachmaninoff, Ellie Matt, Beres Hammond, Kenny Rogers and no Bob Marley. No more music in my apartment. I stopped reading—one of my great loves. Dostoevsky, Sonia Sanchez, and even the juicy gossip from Page Six was unappealing. I was making excuses not to see my cousins who lived less than twenty blocks away. I sank into a deep depression. I did not know it at the time but that stress was causing physical, emotional, and psychological strains that were affecting my overall health. I was sleep-deprived, getting migraines, feeling dizzy. Later, I suffered from vertigo. I was always exhausted. I was grinding my teeth in my sleep. I had never done that before. I would wake up with my jawbone and teeth hurting. I was depressed, anxious, sad, irritable, and confused. I did not know how to pull myself from under the weight of it all.

Many survivors of childhood sexual abuse develop a way of coping with chronic stress and trauma. Many of us indulge in overeating or undereating. We may develop eating disorders. We may develop gambling, alcohol, shopping, and food addictions to cope. We may become promiscuous, engaging in compulsive

sexual activities. During the first year, I became an undereating recluse. The thought of sex was revolting.

My father had visited me in New York before my memories returned. I think it was the year he was going to China for work. We went to the Statue of Liberty, the World Trade Center, restaurants, and Central Park. In April 2002, after my memories came back, I tore up every picture of him in my apartment. I threw away everything he had given to me. I wanted no part of him in my apartment. I purged him from my life, but he was still there. He reentered my life through the triggers and they were unrelenting. I could not escape him.

Triggers are internal and external events that cause someone to remember a negative experience. Many survivors have triggers that are attached to their childhood trauma and abuse. I never heard of the word trigger until I experienced it first-hand. Triggers are personal to the sufferer. They can be just about anything. Triggers can be a smell, a touch, a person, a sound, a word, the environment you are in, a memory. Triggers do not come with an identification tag or warning sign. My body, mind, and spirit, my entire nervous system, was reacting to an image that, on the surface, had no connection to my childhood trauma. Still, that image caused my body, mind, and spirit to react in a powerful negative way. The only way I can describe it is that you are bleeding out. You are awake and can feel yourself being torn and cut. The wounds are left open to the wind and they are stinging. You feel every inch of the pain, but you have no energy to even call out for help.

If a random trigger caught my senses, some aspect of 'the movie' of being sexually abused would appear before me. My involuntary reflexes varied with every trigger. I was like Pavlov's dogs unconsciously reacting to stimuli deep in my subconscious and unknown to me—regular everyday sounds, smells and visuals, became triggers. Sometimes I would just stare unmoving at the thing that triggered me. Other times I would say, no. More often than not, I would run away crying.

Triggers brought disconnected pieces of my once repressed memories. My personal triggers were everywhere, and they could be just about anything. Triggers could be the sound or pitch of someone's voice. It could be someone I have never met if they said a word a certain way. I was triggered by my face. Seeing my face brought the details of my abuse up front and center. When I saw my face, I saw my father. I was terrorizing myself. Another personal trigger was the color gray black. It was the color of my father's underwear. The one he wore when he sexually abused me.

I discovered a new trigger one day. I went to a matinee to catch the first showing of a Bruce Willis movie. I liked matinees. The tickets were cheaper, the popcorn was fresh, you had the theater to yourself and got home in time to do whatever you wanted for the rest of the day. The movie had barely started. Bruce Willis appeared on the screen. I did not hear one word after that. It was like my brain put the film on mute. My eyes were fixated on the space between the base of his nose and the top of his upper lip. That road of flesh on Bruce Willis's face

was triggering me. I felt like I had been electrocuted. I was in shock. Motionless. The distance between Bruce Willis's nose and his upper lip was identical to that of the demon who sexually abused me. I did not understand what was happening.

I kept repeating in my mind, *What is this! WHAT IS THIS! WHAT. THE. HELL. IS. HAPPENING?!!*

My head spun from left to right, trying to see if anyone else was seeing what I was seeing. Everyone was eating popcorn and watching the movie. When I looked back at the screen, I didn't see Bruce Willis's face. I saw the face of my father. The man who abused me. The recollection was too overwhelming. I was dizzy. I did not know it, but vertigo had my body on the move even though I was still sitting. That lip to nose distance had put me in a tailspin. I scraped myself out of the chair, fumbling for the railing. I stumbled down the stairs and out of the theater. I dragged my hands along the side, feeling my way to the side of the theater. I kept my eyes closed because opening them was making the vertigo worse. I was spinning and spinning. I started to feel nauseous. I had to shut down one of my senses to stop from tipping over. I stayed there for a long time. I eventually drove home.

I remembered thinking, *What else lord! What else? I can't keep this up.* I was losing control of my life, the haunting memories, triggers, depression, insomnia, feeling empty, and now vertigo?

The night of the Bruce Willis movie I didn't sleep for two days. I needed out of my body, out of the nightmares in my mind. On the third day, I took a fistful of sleeping pills. As the

pills took effect, I sank into the oversized welcoming arms of my purple sofa. Falling away, drowsy, and relieved. It was quiet in here, the space I was entering. The flashback couldn't get me. Bruce Willis's nose-to-mouth road couldn't get me. The running dream couldn't hurt me. I was safe. 'They' couldn't find me inside this new space. I woke to the sound of the street cleaning truck under my window. Disappointed. Stuck. I was not living, but I was not dying. I was stuck.

My episodes with triggers could put me out of commission for as much as three weeks. I was already an introvert, but I began limiting my interactions with the outside world to extremes. I went to work. I stopped going to church. My mother and my little brother were hundreds of miles away. My cousins and aunts lived relatively close by, but I didn't want to answer the questions that my face and demeanor provoked, so I stayed away from them. It was easy. On Friday nights after work, I would get all that I needed for the weekend. Food. Sleeping pills. Do the laundry. Pick up dry cleaning. Everything was done with the focus of not being disrupted by triggers.

Something had to change. I couldn't make a new face for myself. I couldn't stop the nightmares. So, I tried to control the little that I could. That was my coping mechanism. I limited my interactions with anything and anyone that could bring on triggers. Intuitively, I knew it was time for me to leave New York.

I moved to a new city. I was very careful in decorating my apartment not to have any stressors that would trigger or drag me into depression. I bought bright colorful curtains. I had minimal

decorations. Too many knickknacks would crowd me and make me anxious and jumpy. I kept one photo of my mother, but kept it hidden from view inside a book. I had two photos of my brother. They sat above the fireplace. He was the one person I loved completely. I had no photos of myself on display or hidden.

My neighborhood was quiet. I had found some peace there. I would sit on the patio for hours, breathing in the magnolia perfume from the tall trees that became my friends. The peace I found was sporadic. A trigger would creep into my small, tightly knit world and bring chaos. Up until this point, I refused to seek professional help. In my culture, only crazy people got their heads checked out. If anyone you knew found out you were in therapy, you would be laughed at. But I was desperate and living in America. No one in St. Kitts would find out, so I was beginning to consider getting professional help.

Through therapy, I learned I was suffering from post-traumatic stress disorder (PTSD). I was astonished when my psychiatrist told me this. In my naivety I thought only soldiers had PTSD. I had never been a soldier or fought in any war. "Isn't that how PTSD developed?" I asked my therapist.

I remember her answer: "You are in a war right now, Wen. You are trying to make sense of the senseless things that you endured when you were a child. That is the war you are fighting—the war inside yourself."

I allowed her words to soak in. It took me several minutes to mentally process what my therapist had just said. Nodding, I knew she was correct. My psychiatrist explained my daily

life in a way that I never considered before. I didn't feel alone anymore. Other people, who were not soldiers, had these types of struggles that I was battling.

According to the Mayo Clinic, PTSD can be triggered by terrifying adverse events. PTSD can be immediately experienced, or it can take years to show up. Some symptoms of PTSD include:

1. flashbacks
2. overwhelming shame
3. overwhelming guilt
4. negative thoughts
5. trouble concentrating
6. feeling detached from family
7. feeling detached from friends
8. difficulty having close relationships
9. feeling emotionally numb
10. trouble remembering things
11. hopelessness for the present and future

I checked all the boxes.

The wounds of abuse and trauma take over your entire life. Childhood trauma wounds affect your body, mind, spirit, relationships, behaviors, and thoughts about yourself. Something as simple as your posture, the pitch of your voice, and even your speech pattern can change due to trauma wounds. We may not even realize this until it is drawn to our attention. The trauma has seeped its way into our bodies, minds, and spirits. As abuse

survivors, we become that pain. No matter how hard we mask our depression or low self-esteem from others, our bodies tell the truth that we try to hide. I was living that every day.

Before my memories came back, I was confident, outspoken, and pleasant enough. I walked the same way my mother did. I walked like I was going to cash my five-million-dollar lottery ticket. After my memories returned, I was like a slough.

I don't remember ever telling anyone about experiencing triggers and their effects on my life. Who would I tell? My mother? My relationship with my mother is stitched in the whippings she gave me. Her refusal to apologize and our long-haul dysfunctional relationship introduced me to my mother's own inner turbulence, which needed attention. Mother didn't have the capacity to help me with my trauma wounds, nor did I want her to. I had long stopped going to my mother for emotional support. I had to fend for myself.

During this period of my life, I did not trust anyone who was close to me. I had my cousins, but they were in different cities living their lives. Silence was how you showed your strength, right? If I were to connect with my friends, I would have to tell them the whole shameful story about being sexually abused by my father. I did not want anyone else to know. I was already dealing with enough as it was. My will was taken from me as a child. My voice was taken from me.

Being triggered taught me a lot about myself. Even with the trauma wounds, I thought I could fight for little Wen somewhere inside of me. I was losing the fight for my sleep life, but I could

figure out the moves to save my awake life. I couldn't stop the triggers, but maybe I could diffuse them. I became very aware of the effect an environment had on my physiology. My body, mind, and spirit showed me how I was being affected by this new identity as a survivor. This trinity became my awareness alert system. It took many years to listen to this system, but I was tuning in and learning to recognize the signs.

For example, one sign was clutter. Inside my mind always felt crowded with the memories of being abused. So, controlling the space and environment helped me feel less stifled and less anxious. I spent most of my time at home. It needed to be clean, quiet, bright, and clutter free, a safe zone. I had practical furniture. There were no fluffy pillows on my bed. There were no paintings on the walls. The dishes were packed away, and the kitchen counter was free of toasters and jars of pasta. I needed my line of sight to be unencumbered by "noise" that would further crowd my mind.

For many adult survivors of childhood sexual abuse, our emotional development was stunted. Fear rapidly replaced hope. This is a paralyzing fear that will take all the strength you can muster to overcome it. The suffering child inside of us is waiting to be healed. We fear the suffering so much that we run from the view inside ourselves, our memories. If we were to reach inward to acknowledge some of our wounds, we would touch the beginnings of a great source of healing.

Until I saw all my wounds and listened to them, I was exhausting myself with the burden of fear. Since my memories of being sexually abused returned, all I knew was negativity, nega-

tive thoughts, fear, shame, pain, anger, depression, hopelessness, and emptiness. In a way, the negativity was comforting. It was familiar and the outcome was guaranteed. I was miserable and sad. I could not change my face, the face that terrorized me, but maybe I could change the fear. I could take a chance on myself. I had already been to the bottom of the bottom. I could stay there and try again at dying or I could try to save myself.

Journey to Self:

1. Who was or is the hero in your life?
2. Do you believe you can become your hero?
3. How has your childhood trauma affected you physically?
4. How has your childhood trauma affected you mentally?
5. What happens when a memory of your trauma interrupts your life?
6. Have you ever been triggered?
7. When did you first become triggered?
8. Did you tell anyone what you experienced during your first trigger?
9. Do you know anyone who experiences triggers?
10. Have you found a way to defuse your triggers?
11. How do you calm the internal chaos caused by triggers and the effects of childhood trauma?
12. Have you discovered a safe space to pour out your fears?
13. Where is your safe space and what do you do? This could be a place you go to or an activity you do.

What I have learned:

You are your constant companion. Even if your face is not identical to the person who harmed you, your memories live with you. The environment in which you live may trigger negative memories from your life, whether you want it to or not.

You can lie to the outside world, but when you enter the room of your house and the room of your soul, you will meet yourself there.

Physiology is the scientific understanding of the function of living things. Being sexually abused by my father deeply affected my physiology, from my cells to my behavior. My relationship with myself confirmed this. For me, triggers made me experience the feeling of being traumatized all over again.

If you are an introvert and spend most of your time alone, your journal becomes your safe space to share the truth without judgment. Your journal becomes your "truest friend". A safe space where you can pour out the pain. Journaling can help us examine, learn, and understand ourselves, and perhaps even limit our exposure to that trigger until we have healed a bit more.

Habits that Help my Healing Journey:

After I experience a trigger, I journal. I journal as soon as I can after recovery. I grab my phone or an actual notepad. I log where I was and what I was doing just before the trigger. The time of day. What my environment was and what sounds I heard. What was I wearing? What touched my skin? What had I been eating and drinking? What was I thinking about? Just before the trigger, what was the view in front of me?

4

Under to Inward

Does time heal all wounds? Time showed me wherever I was in the life cycle of my relationship with myself reflected the state of my relationships with my family and few friends. If I was suffering with depression, I had no connection with anyone because I could not connect with myself.

In 2002, I did not have the awareness that I have now. What I had was a big lump of heartbreak, betrayal, and an I-am-a-nobody feeling. The old memories of being sexually abused by my father were ripe and dank. Those raw memories were crowding my every inhale. I was choking on the fact that I was genetically connected to a child molester, a predator, a sycophant, and a manipulator in chief. My father. The terrorist. He was a violent shadow of a human, who shrouded his demented cruelty with charm, wit, and false compassion. I became his weapon. The weapon he used to praise wickedness, upon me and upon others. The things he did to me and the things I witnessed in his presence profoundly affected my well-being and physiology as a child and as an adult. I became a weapon that I used to hurt myself and others.

Where was mother in all this? She played her part.

My father and I would drive around our entire island at least one Sunday per month when I was a girl. St. Kitts is roughly twice the size of Nantucket, an island near Cape Cod in the U.S. state of Massachusetts. Back then, the trip around the island took about an hour. My father was driving his silver car. It was a Rover SD1. He had bought the car that year. It was not a new car, but it was the only one on the island. Everyone knew that car and who the driver was. The colonel. We were driving through a stretch of road in the countryside. There were sugarcane fields to the left and to the right of us. Not a house was in sight, not even on the hills up ahead. As we drove back to Basseterre, the capital city, we saw a man walking along the patch of dirt that separated the street from the cane field. He was headed in the direction that my father was driving. My father was driving on the left side of the road, the same side the man was walking. My father saw the man.

> *My father: Look he lookin' a lift.*
> *Wen: Yeah. Hmm um.*

As my father watched the man in his side-view mirror, I watched the man in the rear window of the car. My father slowed down and stopped about four car lengths from where the man was walking. Grinning and waving, the man jogged towards the car, happy to get out of the mid-afternoon sun. It was at least two miles walk to the next village and at least fifteen miles from

Basseterre. My father sped off as the man neared the left side back bumper, getting ready to reach for the car door handle. I was surprised. I was confused. My father looked pleased. He was chuckling. I remembered giggling and thinking daddy had played a joke. He would reverse and let the man in the car. But my father kept driving.

> Me: *Daddy, you driving off?*
> My father, gruffly: *Yeah, man. I don't want him in here. He gonna dirty up my car. He can't come in here! No way.*

I looked at the man through the rear window. His head was bent and swinging like a metronome. I looked at my father. He was laughing. I remembered thinking that was not nice. I did not share these thoughts with my father. I did not understand why my father pretended to give the man a lift, then drove off. It was as if my father was playing a game only he knew about. He had forgotten to tell the rest of us, me, and the man. I kept looking through the rear window at the man. He was still there. Standing by the side of the road. Waiting. As my father kept driving, the man grew smaller and smaller. His metronome-head still swung. Before my repressed memories returned, my father was my hero. He was not my hero that day on the drive to Basseterre. There are other disjointed memories like this from my childhood as well.

When my cousin Deidrea and I were children, we were as close as sisters. Deidrea and my best friend from elementary school,

Julie, were my dearest friends. My brother had not yet been born. Deidrea and Julie were very kind to me. They listened to me and comforted me after the whippings my mother gave me. Deidrea and I lived two houses away from each other. Almost every day, she would come through the alley where I lived and call me out to play or ask to come into my house. Seeing her was typically the highlight of the day. For some unknown reason, I would suddenly become mean toward her. A particular occasion stands out. One afternoon Deidrea was calling me from the alley. I was at the back of the house in my bedroom. I walked toward the sound of Deidrea's voice, listening. She stood in a short red jumper with bows, trimmed with a yellow border at her shoulders. Her hair was in a bun. Deidrea was standing about ten feet away from the window where I was. She was standing at the two o'clock mark. I was at the six o'clock mark.

I knelt on the sofa and watched her calling me through the slit of the metal louvers in my front room window. I did not reply. As I watched her, I was detached from the experience emotionally. I felt nothing for her—no remorse, guilt, sadness, no glee for perhaps pulling a prank on her. I felt no liking toward her. I felt no love for her. She was not familiar to me. It was as if I were in the audience at a foreign language play. The translation was delayed by several minutes. I watched Deidrea walk toward the steps attached to the house next door. The steps were directly across from the window where I knelt. Deidrea sat there for about fifteen minutes, waiting. Perhaps she thought I was asleep or was out with mother and I would show up soon.

My mother did not allow me to go beyond the perimeter of our house if she was not at home. When she was at home and had given her consent, I could go five yards beyond the perimeter. I am not exaggerating. My mother was very strict. Eventually, Deidrea got up off the steps, walked out of the alley and back to her house. From the sofa, I watched Deidrea until she entered her yard gate, then I sat on the sofa. I stayed there until my mother came home from work. Numb. Why did I treat my beloved cousin so poorly? I have no idea. In retrospect, I believe my mind was soaking in and reciprocating the cruelty I was receiving and witnessing. Later, when we were in our twenties during my healing journey, I apologized to my cousin Deidrea for how I mistreated her when we were children. She did not even remember the incident when I ignored her calls.

There were other examples of my callous behavior.

One of my early boyfriends was kind, funny, caring, and intelligent. He was a giant of a man at six feet three inches, with shoulders as wide as the Pacific Ocean. I was five feet five inches in heels. His home life was challenging. We tried to take care of each other in a way we were never taught. One night we argued about something I cannot recall. We had just left my house. I was driving him back to his house. I was shouting at him, berating him, and lashing him with fireball cuss words. I saw him sink to the size of a child into the seat. That did not stop the tongue lashing I gave him. We took the bags out of the car, through the gate, up the stairs to his front door. He kept pleading with me to stop. I kept assaulting and cutting him with cruel words.

Just as he found the keys in his pocket to open his front door, he defecated himself. Did my unrelenting and violent verbal abuse cause that reaction from the man I cared for? I believe it did. My mother was renowned for the caustic words she spewed when she was angry. I was becoming my mother. I was deeply ashamed of my heartless and appalling behavior.

I apologized to my boyfriend the night of the argument. I begged him to forgive me for the vile and hateful things I said to him. I had hurt him a great deal. How could I have been so cruel? He did not deserve any of it. No one did. I did not want to become my mother. I did not want to hurt anyone, especially those who cared and loved me unconditionally.

Does time heal all wounds? My childhood wounds were sucking the life out of me. I was too mentally worn out, and physically and spiritually stressed and terrified to give them the much needed attention they deserved. What I did not know at the time was that my wounds are like children. I knew each one of their names; their first name, middle name, and last name. But my wounds had the inherent propensity to become unhealthy. Time showed me that each of my wounds grew stronger and unhealthier every second I ignored them. Whenever my wounds showed—nightmares, triggers, depression, flashbacks of being sexually abuse, and deep feelings of shame and self-hate—I would surrender my will. If I'm frank, there was no will to surrender, because I had no control to begin with. These untreated wounds were living rent free in my every thought, emotion, decision, behavior, and relationships.

Emotionally and psychologically, I was stuck at eight years old. The girl within me, my inner child, her wounds were running relay races inside of me, passing the baton from wound to wound. It felt like I could not even get even a millisecond time-out. My triggers passed and shuffled my childhood wounds to flashbacks, then passed them on to the night terrors, then passed those wounds on to shame, depression, and on and on. Back then, I did not know why I was behaving this way. I hated myself for my behavior and for not understanding my behavior. I was rotting from the inside out. Where and who could I turn to?

Many years after leaving St. Kitts, I still needed help. I could not get out of my physical and mental urn. I didn't know where to begin. I was in a dilemma. I was in denial about the weight of my struggles, and I was petrified. Intuitively, I knew I had to dig deep and face the dark pain, but my gosh it could break me! I desperately needed to sleep. Most of all I needed to feel human, to feel whole. I had a running monologue going as I paced my apartment at night:

I could try therapy?
What? No way!
Well, therapists were always on The Oprah Winfrey Show.
Where was I gonna find a therapist? And find a therapist that understood my messy story and my struggles?
Please, this is America. America got all kinds of doctors. If you're sick with something, America's got a doctor for it.

There weren't any black female therapists that I ever heard of. All the therapists that I saw on Oprah were white! No degree could prepare you for the taste of the life of a black sexual abuse survivor. I needed a shrink that understood the code of living in brown and black skin. I needed them to understand the whole story, not just the Freud piece.

No, I was definitely not going to a white therapist, and I was absolutely NOT going to a white male therapist.

*The last white male doctor I went to was a gynecologist. **He laughed when he was examining my vagina! Yeah, he laughed!** I had examined my vagina. It looked regular to me. The outside looked like the women in my family's vagina. The rest of my vagina looked like the vagina I saw in biology textbooks, magazines, and movies. My vagina didn't have any fangs. That piece of s___ mutha___ doctor!!*

HELLZ TO THE NO! Not doing that again. Was too humiliating. No, I won't be able to find a therapist that would understand living while being a black woman in America. It sure was different from the freedom-life in St. Kitts.

Nar, I wouldn't be able to find a therapist who genuinely cared about helping me and my messed-up life.

On top of all that, I sure did not want anyone in my family finding out I was in therapy. My family, not just my mother, already thought I was strange. If they heard I was in therapy, the first thing they would say was OH! See! A tell all you she crazy!

For me, this was not a racial issue. I wanted to work with a black female therapist who understood the journey of a black

woman. Since I was a child, I had a diverse group of friends. I had friends that were of Lebanese descent, African descent. I had Chinese, Caucasian, and Indian friends. Even when I moved to America and later to Europe and realized that people saw you as "race first," I continued to live the values my mother had instilled. My mother's code was: No one is better than you. We are all humans who bleed. People need you and you need them. One hand can't clap.

That white male gynecologist who laughed at my vagina surely did not get the message my mother had given me from his mother!

So, I decided to tough it out and skip therapy. I continued living my pretend life.

I pretended to be what some people call a progressive career woman. I put myself through college, moved into my first apartment, had a dream job, and lived in New York. I was on track to being promoted after only nine months on the job. What more could a twenty-something ask for? At times I even fooled myself. That did not last long. My childhood wounds were there, waiting for me when I closed my apartment door. They were sitting and watching me as I ate breakfast. My childhood wounds were watching me as I washed my hair. They were waiting while I cleaned the bathroom. These wounds were laughing at me through every nightmare.

Intuitively, I knew I had to "get to me." I knew my beginning story, my childhood. I knew some of my middle story. But where was the real Wen in all of this? I could not discern whether my emotions, feelings, and behavior were of my creation or if they

reflected the effects of being abused by my mother and my father. I was lost and thoroughly confused. I felt like a piece of thread, scaling the wind and falling to the ground, rolling, latching on to whatever would have me. I needed to "get to Wen." I needed help from someone who dealt with my kind of troubles.

At this point, I had confided in my older cousins Heather and Deidrea about being sexually abused. They already knew about the whippings from mother. She was their aunt. My cousins had long since heard about and witnessed my mother's wrath. Deidrea was more worldly than Heather and me. She worked at MTV and met all sorts of people. Deidrea told me about a friend of hers who was struggling with some life issues. Deidrea said her friend had gotten help from a "Woman in DC." This woman was not a therapist or a psychic, but this woman had given Deidrea's friend insight that had helped.

That's what I needed. Help. This may sound strange, but I was comfortable speaking with the "Woman in DC" who I had never met. My mind and body may have been out of my control, but my intuition strengthened. My spirit was telling me this was the path that I should take. I forged on, trusting my intuition.

Within a week of that conversation with Deidrea, I spoke to the "Woman in DC." We spoke for less than twenty minutes. I told her that my mother had physically abused me as a child. I told her that my father had sexually abused me. I told the "Woman in DC" I could not free myself from the memories and the shame. I told her I felt empty, lost, and confused. The "Woman in DC" listened without interrupting me. Finally, she spoke.

Woman in DC: "You're not all together. Your body's one way. Your mind another way. Your spirit one way. They got to connect for you to see. But first, you got to listen."

Wen: "Listen?"

Woman in DC: "That's right."

Wen: "What do you mean, listen? Listen to who? Listen for what?"

Woman in DC: "Listen for you."

The conversation ended soon after. I replayed it in my head again and again. Listen for me? How could I listen for myself when my mind was all over the place? How could I become "all together"? This sure was some "mumbo-jumbo," I thought. It took me several years to understand what the "Woman in DC" told me to do. It took many more years for me *to do* what she told me to do. Listen *for* me.

Adverse Childhood Effects (ACEs) shaped my development as a child and lingered into my adulthood. Through my continued love of reading, I learned more about ACEs. Survivors of childhood trauma and abuse have higher rates of depression, anxiety, addictions, and risks of heart disease. Childhood trauma and abuse have long-term effects and often follow the survivor into adulthood. Many studies have proven this connection, including the Adverse Childhood Experiences (ACE Study) conducted from 1995 to 1997. The ACE Study investigated the impact of childhood abuse on the adult survivors' health and well-being. The researchers studied the relationship between

ten adverse childhood experiences (ACEs) and adult survivors' health and behavior. These ten ACEs included the following:

1. childhood physical abuse
2. childhood sexual abuse
3. childhood emotional abuse
4. emotional neglect
5. witnessing domestic violence against the mother
6. physical neglect
7. mentally ill, depressed, or suicidal person in the child's home
8. drug-addicted or alcoholic family member
9. incarceration of a family member for a crime
10. loss of parent due to death or abandonment

How many of these were part of your childhood story? How many were a part of mine?

I learned the most essential developing organ we have is our brain. A study by Dr. Allyson Mackey at the University of Pennsylvania published in Nature Neuroscience Reviews found that unresolved trauma could cause those affected to become sicker and die younger. The study concluded that poverty, stress, and adverse childhood experiences appeared to cause children's brains to grow too quickly. Their bodies also developed too rapidly.

I started puberty at eleven years old. I began to menstruate at twelve years old. At the time, I was living in St. Kitts. I don't think one could blame my early development on growth hormones used in food production. Much of what I ate was produced locally

by Kittitian farmers and butchers and sourced from the Atlantic Ocean and the Caribbean Sea that surrounded the island.

Survivors of childhood abuse and trauma are not allowed to be children. I was conditioned to accept what I received. I was conditioned never to ask questions. The effect caused me to distrust and doubt my intuition. This conditioning affected how I regarded myself; ugly, pretty, scary, unintelligent, foolish, wise, disconnected, and confused. I could go on. I didn't share the inner turbulence of my self-doubt and negative dialogue with others. The people I encountered may even have believed I was cool, fun, and happy. That's the mask I wore. It was my attempt at avoiding any questions. These questions could topple my precarious internal systems built on fear, shame, anxiety, depression, and the myriad of battles I was fighting.

Until 2020, I did not have any pictures of myself as a child. For many years, looking at that girl brought an onslaught of PTSD. I never told this to anyone other than my therapist. I was grieving for the child who was not allowed to be a child. Even now, after fifteen plus years into recovery on my healing journey from childhood sexual abuse and trauma, I still hurt for that innocent girl, the wounded child within me.

During one of my mother's visits from St. Kitts, I remembered seeing a picture of myself. My mother always carried family photos with her whenever she came to visit me. In this picture, I must have been five or six years old. The photo was taken in St. Kitts. The girl in the photo was so foreign to me, yet she was not. I was in the alley by my mother's house. I was smiling. I

was wearing a red tank top and black shorts with a white trim and long socks to my knees. I was all skin and bones. My hair was in plaits. I looked happy.

When I rested my eyes on that little girl that was me, I started sniffling. Then I was crying, quiet years of tears. The tears traveled down my blouse into my work skirt and landed in my lap. There she was. I could no longer run away from her. I had huge white teeth planted in the shiny brown lollypop face with moon shaped eyes across my entire face. A little girl that was never a child. Even now as I share this story I begin to tear up. As I looked at the photograph of myself as a child, thoughts ran through my head.

Were you ever really a child, little Wen? My memories of you begin when you were forced to become a woman; a woman at eight years old.

You were not protected.

You had no voice.

You had a kind and open heart, I can see in this photograph.

Your childhood had just begun, and it was soon to be over.

You were not treated like a child, you were treated like an adult.

You were pushed to grow up. Quickly.

Your homes were never safe, not your mother's, not your father's.

Did you truly ever feel loved in actions and words?

Did anyone ask you what was happening in your world and in your daily life?

I am so sorry you suffered so.

You had nowhere to go, did you?

Did this photo prompt a forgotten memory? Not consciously. My earliest proper memory was when I was eight years old. I know for certain down to my cellular level that little girl was suffering at a fragile stage of her life. Fast forward twenty plus years and I felt a death, deep inside of me, as I stared at the photograph. I felt the death of little Wen.

It felt like trauma was to be my lifelong companion.

For some of us, the survivors of childhood abuse and trauma, our wounds are as old as our chronological age. Inside the survivors of childhood abuse and trauma lives a wounded child. This child has never aged. This child is stuck at the stage that trauma and abuse was put upon them, waiting.

The inner child is waiting for us to visit and to listen. The inner child is waiting for us to learn and to understand their whys. Why they suffered. Why they hurt. Why they acted out. The inner child is longing for us to comfort, care for, and love them. In that photo was little Wen. She was calling me, begging me to keep acknowledging her wounds. The wounds that were living inside the adult me now and would surely break whatever was left of my mind. This suffering had become my haunting.

I remember a conversation I had with my mother when I was in my early thirties. It was less than five years *after* I told her my father had sexually abused me as a child. It was about six months after I started therapy. We always got dressed up when we went out. We both wore bright-colored A-line dresses. Mine was a leopard print beige, orange, brown, and yellow. I can't remember the colors of mother's dress. Mother looked regal with

her floral headscarf effortlessly wrapped like an African queen. The construction of the wrap was intricate. It was arched and tucked like only she could do it. Mother did not even look in the mirror when she was wrapping her head most of the time.

I was happy to be on vacation and spend one-on-one time with mother. The plan was to run errands, then we would have a nice lunch and catch a movie. Mother has an easy-going way about her. She never asked for much. To her, this outing was the equivalent of going to a spa. We stopped by the drive-through window at one of the neighborhood banks. As we were driving out of the parking lot, I said something. I don't recall anything that prompted these words or even thinking about saying them. They found their way out that day, finally.

"You really hurt me, mummy, the way you used to beat me so bad."

I felt her eyes before I saw them. She was looking at me in stunned silence for what seemed like a full minute.

Mother said in a dry, flat tone, "Well, look how good you turned out."

I couldn't believe what I had just heard. My mother's response made me feel as if I had been forcibly submerged in the ocean. Someone was pressing my head down and holding me just so while I flared and scraped for oxygen. Sitting next to mother in the car, I did not even realize I had stopped breathing. I looked at mother and she met my gaze. I was baffled. I then looked straight ahead and drove aimlessly out of the bank's parking lot. I saw the cherry blossom trees lining the streets through

the windshield, shedding pink and cream confetti petals and weaving flights on the warm breeze. Inside my two-door car with my mother less than fifteen inches away, I was also shedding, falling away from myself. A hurricane of emotions thrashed about within me. I felt anger, heartbreak, sadness, betrayal, hopelessness, lovelessness. I felt abandoned.

I tried again. Softly. "Can't you apologize for beating me so much? Can't you apologize for hurting me like that? Can't. You. Just. Apologize?!"

She said again, "Look how good you turned out."

I could not believe what I had just heard. In my mother's estimation, I benefited from the beatings. From her perspective, she did me a favor. After all, I was the first person in my immediate family to have an undergraduate degree. I had just bought my first house. I had a decent paying job. I wasn't on drugs. I was focused on my career. I was not a party girl. I was not promiscuous. So, based on her standards of personal development, her parenting was a huge success. I was anointed by her whippings. They put my life on a marvelous course. In that moment, I felt like my mother was whipping me again. She was whipping me for asking such a stupid question.

My mother was whipping me for breaking the code of silence that was the family inheritance. This woman was whipping me for not being strong enough, like she was, to not show that I was still wounded by my childhood trauma. My mother was whipping me for questioning her parenting style. In that moment, I also realized that mother's pride was impenetrable.

My mother was like a thing in head-to-toe cast iron armor with her pride intact—you felt and saw eyes, that's the only inclination that the thing could be human.

My mother and I were living in different realities. Her "Parents are Gods" mindset was her reality and all others were irrelevant. Later, I came to understand it all. I understood that for my mother to acknowledge the wounds she gave me, she would have to touch a part of her inner child that had suffered a similar fate. At fifty-plus years, my mother was not going to do that. Fast forward several years, I would learn that even at seventy, my mother's pride was still snugly fitted. Her pride-armor was shiny and intact. It was her lifeline. It will be her legacy.

Get your act together—these were the reckless words I heard from "loved" ones. No one can make a survivor "*Get their act together*" or "*get their life right*" until that survivor is fully ready to do the work. Is this what the Woman in DC meant when she said I had to listen for myself? Did she mean I had to do the work of looking inward and listening for what I was feeling? I believed that was at least partially what she meant. I had to become self-aware. I had to become a witness to the thoughts that eventually became my expressions and emotions. It took more courage than I thought I had the capacity to find. For who would walk into a burning house to save someone they have never met? I sure was not ready to do that. That's how it felt for me.

You see, until I healed the wounds from childhood sexual abuse and trauma, I never would meet the peaceful, hopeful, nightmare-free version of Wen. I could never create a new version

of myself. There was no proof she ever existed. The traumatized version of Wen was all I knew then. I hardly remembered a life before the memories returned. I was barely keeping it together. I was living day to day trying to breathe. How the hell was I going to have the strength to deal with "wound healing"?

Healing the inner child was painful business. I was getting an understanding of what it could entail and wanted as little as possible to do with that "healing business." I had to let myself inside my tightly stitched wounds. I had to become vulnerable. This meant reopening the big old pains and inspecting them one by one. Why would anyone ever want to do that when they could just move on? I returned to journaling, my safe space.

In my journal, I mapped all the hurts; the people and the environment I was in when I was hurting. From my self-work, I understood what caused me pain, and the pain itself was not my pain. Someone had programmed me to believe that I was the cause of my pain—that the pain was "my" pain! This was a big revelation! The hurt I felt as an adult when I was putting fade creams and cocoa butter, night after night, on the scars on my legs—the scars that mother gave me—brought up a harsh reality. Back then, I believed I was a bad child, who deserved to be whipped. I no longer believed I was a bad child who deserved such treatment. My mother was using me as a vessel to empty her pains into. The cause of the pains was her own history of suffering. The pains I thought were mine were indeed hers. This revelation resulted from a lot of self-work and listening to the one person I had to learn to trust: myself.

I reviewed the pages in my journal where I had written about being triggered. Reading that section of the journal helped me track the hurt and the triggers through to the times I felt depressed, then through to the moments the feelings of depression were lifted. I revisited what I was doing, feeling, and if anyone was with me. Was I single at the time? What was I doing during that period of my life? I had been writing it all down for some time now. My journal did not judge me. It did not argue back. It just filled up its pages with my case. I had become my own case study.

From reviewing my journal, I saw curious patterns. It showed me connections between the chaos inside me and the conditions that made me feel depressed. I discovered New York had too many triggers and put me on a perpetual merry-go-round of feeling empty. I loved living in New York. I loved trying to ice skate, going to plays, concerts, and museums. There was always something to do and *that* was the problem. The noise. The noise of the city was far too loud. The noise of the machines, buses, trains, taxi cabs, horns, music, and voices. The noise of the people as they worked those machines, the people as they made their choices of what to do with their day. New York's noise and the staggering noises in my inner life were too overwhelming. It was too early in my healing journey to navigate the external noise and the triggers they instigated while simultaneously trying to hear myself. It was time to leave the city of my twenties.

When I left New York, I continued journaling. I continued to record my thoughts and to find patterns of behavior. I discovered

one thing that continuously pulled me out of my depression. It was a piano movement. It was the sound of a particular piano movement. Rachmaninoff's Elegie Op 3. No.1. I had started to listen to instrumental music once more, classical and jazz mostly. I could hear the individual melodies that were strung together into a chandelier. The music was rendering a new energy, a movement inside of me. I was remembering my first love. Music.

I began studying classical piano when I was around ten years old. My mother persuaded my piano teacher, Ms. Wall, to take me on as a new student. Her "books" were full for the year, but my mother charmed my piano teacher. My lessons were held at Ms. Wall's house, in her living room. The living room was three times the size of my mother's house. There were two baby grand pianos sitting next to each other along the western side of the room. Both pianos had the word Steinway written in gold on their sides. I had never seen pianos like these before. My church had a giant pipe organ and an upright piano, but there weren't any baby grands. Ms. Wall's pianos had roofs and the roofs were unlatched. Inside, the pianos had stairs, at least that's how it looked to me. On the first set of stairs, I could see taut gold strings. On the second set of stairs, I saw wooden parts that Ms. Wall said were hammers. I could see brown and shiny circles that looked like flattened thumbtacks. What an adventure Ms. Wall's was going to be!

The slippery, silky black and white M&M keys felt strange at first. I pressed middle C and its heart tickled me. I looked at Ms. Wall in surprise and I started to giggle with delight. Then

she laughed along with me. I pressed some more notes and felt the piano's heartbeat in my palms, fingertips, and toes. My whole body was vibrating with the piano's sound waves.

I loved taking piano lessons. I liked that Ms. Wall let me have the whole living room to myself before my lesson began. The lessons were on Wednesdays and Saturdays at six-thirty in the morning. No, that was not unusual or extraordinary. That was life in St. Kitts. Most people got up at four or five o'clock to work one of their six jobs. I would walk to my piano lesson and get there by six o'clock to practice my scales. Ms. Wall would come down from upstairs at six-thirty. Until then I had to place to myself. In the living room, the shutter style windows were taller than me. They were always flung open. Often when I sat at the piano, I felt the cool sea breeze. I glimpsed spray painted butterflies and heard birds catching each other's song on the fence nearby. I didn't have a piano at home, but Ms. Wall said I could come early to practice. I liked her a lot.

Ms. Wall was nice and patient. She didn't beat her students on their knuckles when they played the wrong notes like I heard some other piano teachers were doing. I was not good at sight-reading. I was okay at playing a few pieces. What I truly loved was composing. Chopin, Bach, and Debussy were renowned masters who created their own works. Their works still lived on even though they were long gone. I was alive. I was never going to be as good a pianist as those dead people. Plus, I did not want to be anybody's clone. I wanted to write what I heard on my inside. I did not know it then, but those music

lessons in Ms. Wall's living room were to become an essential part of my adult life.

Before I left New York, I had one of the most remarkable experiences that connected me with that ten-year-old girl, my inner child. My cousin Deidrea knew someone who knew someone who worked at a piano refurbishment warehouse. Using Deidrea's connection, I scored a visit after working hours. When me and the attendant got off the elevator, the room was pitch black. The attendant turned on the lights. I gasped, then giggled in delight. I could not believe my eyes. There were rows upon rows of refurbished grands, baby grands, and upright Steinway pianos! The pianos were on display like cars at a dealership. They were white ones, beige, brown, and black pianos. They were all Steinways! Some of them were unfinished.

The attendant said it was okay for me to touch them. I gently rubbed the sides of the unfinished piano, feeling it's long coarse lines. Shyly, I asked the attendant if I could play one of the pianos for a bit. He said yes. I was intimidated. I had not played a piano since high school. I tried one note, tenuously striking F sharp. Although I could hardly hear the note, the vibration traveled through my fingertips. That sound wave resuscitated my spirit and introduced my childhood wounds to sunlight! Entranced, I played the D major chord like I knew what I was doing. The sound reverberated throughout the warehouse, bouncing and filling the space like a choir. I tried some more notes. I couldn't remember any of the pieces from Ms. Wall's piano lessons. It didn't matter that there was no structured melody or that the

chords were too dissonant. I love the sound of minor chords. They reminded me of Thelonious Monk, a jazz composer and musician. I did not care that my playing was rusty as hell. I found my best friend once again. I was back in Ms. Wall's living room, floating in the purity of childlike wonder. I was standing inside inner peace and I didn't want to leave.

As human beings, we study books, courses, languages, music, theories, animals, galaxies, and so much more. The person I never studied was myself. Journaling became the surround sound of my life. It was my call-back. Journaling allowed me to hear myself and to revisit myself at my leisure. Through journaling and rereading my words, I had a chance to listen for me, just like the "Woman in DC" But first, I had to be still to hear myself.

Once I could hear myself, the listening began. I started listening for myself and discovering my voice. I would gradually become fully aware of my everything; my needs, wants, desires, hopes, dreams, wounds, my purpose, and my actions to achieve my purpose. I had to quiet the external and internal noises, all the negative self-talk and thoughts, to get there. It would take me some time to master self-awareness and self-reflection. Unknowingly, I was creating a promise to myself without even knowing it. By listening for myself, discovering my voice, I was looking inward and reflecting on my childhood wounds. I was touching the source of my pains and my joys. I was creating something new. A new Wen.

Journey to Self:

1. Do you experience negative thoughts?

2. Whose voice is whispering negative thoughts to you?

3. Whose voice are you really hearing? Is it the abuser re-indoctrinating you to the belief that you are unworthy of love?

4. Is it your voice whispering those thoughts to you?

5. Do you believe negative thoughts can be quieted?

6. Have you found a way to quiet your negative thoughts?

7. Do you judge yourself by someone else's standards and values?

8. What are your thoughts on self-reflection?

9. Have you tried meditation or just being quiet for two minutes to five minutes?

10. How do you feel after you meditate?

11. Have you tried journaling?

12. If you have tried journaling, what have you discovered in the process?

13. Do you have a particular place where you like to journal?

14. Do you prepare your journaling space in any way to help support your journal practice?

15. What is your most joyful and your most playful childhood memory?

What I have learned:

1. I am not mentally strong. I am "practiced."
2. For me, to continue to heal and create the peaceful life that I need, I must practice self-healing daily.
3. I do not deny or push back my childhood trauma. I honor the past from which I crawled and every day I celebrate my rebirth.
4. At least three minutes per day, I practice the habits that help me heal, achieve, and sustain my inner peace. I draw from this reservoir to refuel my hope and abundant love on days when my energy is low and the wounds show up uninvited.

Habits that Help my Healing Journey:

1. Journaling. Specifically, I write what I am feeling without thinking or correcting any spelling errors. I just let it pour out.
2. Reconnecting with my intuition.
3. Finding a quiet place, removing all distractions, and being still. Some call this meditation. It helps me listen for my inner child; to listen for me.
4. Giving myself grace. Learning to be patient with myself.

5. Becoming aware of where I am – physically, mentally, and emotionally. We do not know that we are *within* knowledge until we become aware that we are *without* it.

6. Activating the childlike wonder inside with something only I can give myself, something that is not superficial.

5

Name the Battle

Do you lie to yourself? How does it make you feel about yourself? Denial is a powerful slave master. Throughout my twenties and for a good part of my thirties, I was "Ms. Tough It Out." Even after doing the work, I still suffered. After looking inward and getting a glimmer of relief and some semblance of inner peace through reconnecting with the mercy of music and journaling, I was still suffering. The adverse effects of childhood trauma were hooked into my veins, feeding my nervous system, thoughts, and dreams, and my definition of Wen. If you have never been held hostage by trauma or abuse, this may all seem incomprehensible. You may be thinking why can't she just get over it?

Overcoming abuse and trauma and healing the inner child wounds is not like getting a heart transplant. There are no organ donor cards. No one checks the box on their driver's license with whom you may be a possible match. There is no waiting in the national queue to get that "matched" heart. Healing the inner child is not like having a broken leg. There is no physical exam that could immediately diagnose your condition. There is no X-ray to spot your pain points. The doctor cannot use

the treatment and rehabilitation protocol she gave to patient number 3,000 to you, the abuse survivor.

Survivors of childhood trauma are running a course of evolving, retracting, cascading, and repeating wounds that are unique to each of us. We often live in the land of perpetual confusion. The healing journey is not linear. The healing journey does not begin in the valley of our pains, we climb to the peak of Mount Everest, then *ta-da!* she's healed, now let's go get Starbucks. There are a multitude of valleys, wildfires, peaks, flat plains, Amazon rainforest, and icebergs. You name it. We experience it. Survivors must muck through it all.

The demented nonhumans who abused and traumatized us fed our minds a diet of self-denial, self-rejection, and self-erasure. For me, one of the results of this nutrition was self-sabotage, unconsciously and consciously. I was becoming what the abusers wanted and needed me to be. Undoing that programming takes a lot of fight. I say fight because every day was one battle after another—for over ten years that's how it felt. There was a lot of physical and emotional pain and mental suffering. I have listed some of my experiences in this book.

One big battle in particular was dragging me down more than any other. It was the longest battle that I fought. I didn't know what it was or how much it weighed me down. So, I lied to myself.

You, the survivors, may know what I am talking about. You have the lies at the ready. The lies we tell ourselves again and again. So often that we bury ourselves with every word.

Family/Friend/Person X: "How are you?"

Me: "I'm good. I'm fine."

Family/Friend/Person X: "You're always so quiet and by yourself. You don't call. Everything okay?"

Me: "Yeah. I'm fine."

Family/Friend/Person X: "Are you coming to the reunion in August?"

Me: "No, I can't. I have some stuff to take care of that weekend."

Family/Friend/Person X: "Six months from now? Your calendar's already full?"

Me: "Yeah."

What happens when we tell these little lies? We go into survival mode. We just want to get through that day. We just *need* to get through that hour so that we can rush home to cry ourselves to sleep. Some of us rush home to eat the entire pantry. We can't wait to be alone to drain every bottle of wine, beer, whiskey, vodka, and gin we've got, or to get a hit of "something."

For me, it was *the event* of my week. Every Friday. Date night. The F train could never screech to Lexington Avenue fast enough. I always made sure to stand near the door at the back of the train. I stood for one hour clutching my purse and counting the stops; Roosevelt Island, Jackson Heights, Forest Hills. Sitting was unacceptable. It would hinder my dash up the chewing gum patched stairs into my "confession booth." The medley of arguments, panhandling, coughing, and flatulence

saturating the train car did not upset the waiting promise—the bodega filled with my dearest love.

What's your dearest love? Mine? Strawberry Haagen Dazs ice cream. I would buy two pints at a time, the almost two-liter size if I found it. I would get home, jump out my shoes, and wash my hands as quickly as I could. I would wash off the ice cream container with dish liquid like only a germaphobe could wash it. That's because I knew what was about to go down. I would take off the cardboard lid. Through the foggy plastic cover, I saw the chunks of strawberry hearts.

Gradually, I eased off the plastic cover and there it was. That fragrant, bittersweet, buttery, pale pink creamy cloud stood at attention. It was decorated with dimpled seeds and was just waiting for me to devour it. First, I had to take care of the topper. With both hands, I licked the plastic container clean. When that was taken care of, I popped the open ice cream container in the microwave for thirty seconds, no more.

Once that bell rang, my spoon and taste buds were at the ready. I ate the entire pint standing by the sink. I had to take care of the "afters." I put my spoon in the sink and used my fingers to dig out the last drops of the ice cream from that container. It felt so good to taste something so cool, rich, and luxurious. It felt good to not hurt. With every spoonful of ice cream, I hurt less and less. With that Haagen Dazs ice cream, me and the trauma wounds called a truce, at least for a while. I was grateful for that.

What was I really doing just before I devoured the ice cream? I was attempting to recreate the one thing I stumbled upon by

sheer accident or fate. You see, while I was nursing ravenous traumas day after day, a thing found its way in.

It. Made. Me. Wobble.

In my twenties, living in the haze of accents and cultures in my New York neighborhood, it found me. Racing through Tennessee's magnolia rainstorm, it stole me. While me and my trauma gullied a life in California, spying the drug dealer as he left the Pacific's embrace, it was there once more. And it made me wobble each time, frothing with anticipation.

I had discovered I could create an internal safe space. Where before I had surrendered to the trauma, I found there was another way.

In that safe space I could disinvite the world of trauma. In that safe space, I could empower myself to choose a variety of options. *Could I eke out a semblance of control of my actions? For even a millisecond, would I not be living at the behest of traumas?* That's what made me wobble. The fresh knowledge that I could wheel my own choices. It seems like a simple nonevent that I had already been doing, just like I had known my name all my life but never knew who I was and what I needed. I didn't know that *I needed to know* this flow that I could harness. I stumbled on an intention that I, Wen, could create from scratch.

I had power? I had power! I had power to lead my life in the direction of my decisions. That awareness bowed one of my mightiest trauma wounds. Fear.

Many survivors of abuse and trauma would prefer not to deal with the pain or to face our fears. It's scary and uncomfortable.

The new unexplained tension does not feel safe. The old religion of recycling trauma is familiar. There is a kind of strange comfort in knowing the outcome. So, we stick with the familiar and use our addictions to cope. We repeat the behaviors or experiences that give us relief, albeit temporary. I had my ice cream, but the truce was temporary.

The wounded child within me was waiting for me to fight to use my power and make decisions that would serve my healing. The more I progressed in my healing journey, the more I would have to touch my wounds, wobble, and use that power of my intention to heal. That experience would sometimes overwhelm my senses with confusing and uncomfortable indecision. I recoiled at the thought of getting near the invisible wound platoon. What kept me going? The flickers of feel-good that I felt about myself.

The flickers were far and few between. Over time, I observed that the flickers required indeterminant degrees of stillness; hardly any human-created sounds in the environment, and they needed my mind to be free of busy thoughts, negative or positive. I also observed that if I was doing something that made me feel safe (writing music) or calm (floating in the sea), the flickers would linger. Some call this meditation. When the flickers came it was as if my tightly packed delayed life had received the promise of dew seeding and cooing hope that I had yet to conceive. If only I could fit my existence into these flickers, then I could be free.

With every step forward into hope and healing, my negative thoughts, I call them Whisper Warriors, were always at the

podium. They were championing my descent into chaos. I had to keep fighting against the programming of my abusers. It was a constant battle to not slip back into the practice of self-sabotage. At times, I would give in to the Whisper Warriors that cradled me in my dark and low moments. They were incessant.

You are crazy.
You are dirty.
You are nothing.
It is your fault that you are like this.
You are a sin.
You are an ugly, nasty black girl.
Spottycolonious.
You deserve what you get.
You're sick and disgusting.
Spottycolonious.
Everyone will find out your father had sex with you. They will point at you and shun you!
Everyone will find out your mother hated you. She never wanted you. That's why she kicked you out when you were sixteen and threw your clothes in the alley for everyone to see how much she hated you. You were a wicked girl who deserved what you got.

These are the words I said to myself. This is how I felt. This is the way I lived. These words would sometimes show up in the middle of dinner after a hard day's work, like a sort of prayer. I thought I had been making progress with my healing journey, but it felt like I was going one step forward and five steps back.

It was time to find a therapist. My requirements were set. Black. Female. An African descendant. Experienced. Qualified.

I had moved to yet another city. I had two friends in this new city. I worked with one of them. She told me that she was dealing with some heavy issues. She said she had found a good therapist. I got the therapist's number, researched her, then made an appointment. I went to therapy for the first time in the summer of 2005. I was desperate and a bit nervous of what would happen when I met my therapist. I had spoken to her briefly on the phone. Her voice reminded me of my maternal grandmother's.

I remember this visit like it was yesterday. My therapist turned out to be a warm, middle-aged lady who immediately put me at ease. She invited me into her small office. There were books, a small coffee table next to a small couch, no plants, and two chairs. One of the chairs functioned as a table for more books. There was no décor to speak of. It was just an office. I remember there was a bag with some words in large print in the chair closest to the entry. I don't know what the words said, but I kept staring at them as I entered the room. We introduced ourselves. I was quiet and went back to staring at the bag with the words.

Black Female Therapist: "Would you like to sit on the couch or the chair?"
Without speaking, I chose the couch.
Black Female Therapist: "Would you like a bottle of water?"
Wen: "No, thank you."
Black Female Therapist: "Wen, can you hear me? Your time is almost up. Wen? Wen?"

On that Saturday morning, I had the most peaceful rest of my life up to that point. There was no nightmare. I sat on that couch and surrendered to the peaceful energy of my therapist's office. When I awoke, I was calm, yet a bit disoriented. As I looked around the room, I began to place my whereabouts. I remember thinking, *Okay, what just happened? What. Just. Happened?! Did that woman drug me with that water she gave me?* Then I remembered. I had refused the bottle of water. I did not drink anything. *I have serious trust issues. Did I just . . . Did I just fall asleep? Did I fall asleep just like that?*

I asked my therapist how long I had slept. She said I was asleep for forty-five minutes. She said she could tell I needed to rest, so she didn't wake me. Those were some of the kindest words I had ever heard. That night the nightmares returned.

Through therapy and journaling, I kept exploring the battles within my mind. I learned that it was easy to articulate and describe the things and experiences that I did not want or need, but it was challenging to identify most of the things I needed. The programming of the childhood trauma had me living in the land of the negative, which trounced positive thoughts, emotions, and hopefulness. This was part of the battle. I asked myself many questions to prompt positive thoughts:

1. Do you remember any happy moments in your childhood?
2. What were you doing in those moments?
3. What did you hear?
4. Was anyone else there with you?

5. Which village were you in?
6. Were you in St. Kitts or another island? Which island?
7. Were there animals, plants, mountains, water?
8. What else did you see there?
9. What do you like about yourself?
10. Why do you like these things about yourself?
11. What do you need most from yourself?

That last question was a doozy. I needed many things. My list was very long. I began writing what I needed in my journal.

1. Sleep.
2. I needed to have a normal brain and a normal life!
3. I needed to hurry up and finish paying off my student loan.
4. I needed to get my teeth cleaned.
5. I needed the spots on my legs to fade, so I could stop putting on Dermablend body makeup to cover them up. Having makeup melting between my toe-crack was No Bueno!
6. I needed to buy my little brother a present for his birthday.
7. I needed to spend more time jogging along the magnolia trees in my new neighborhood.
8. I needed more sun.
9. I needed to find the nearest beach, so I could go swimming. Been too long.
10. I needed to find a new hairstylist. The last one fried my hair with that super relaxer. And he called me chocolate thunder. Inappropriate! Hello!

11. I needed to try that five o'clock yoga class again. Never heard of Yin Yang yoga before then. I liked the easy old people yoga.

12. What else did I need?

13. I needed my neighbor to stop trying to convert me to a Jehovah's-Witness-somebody. It was becoming borderline harassment.

14. OH, and I needed a new cell phone.

According to Maslow, a psychologist I first heard about in undergrad, I was missing the boat on the last question—what did I need? Maslow suggested that humans are motivated by five needs, or drivers, that essentially determine their actions and the quality of their life. I am not a psychologist, but that is how I interpret Maslow's hierarchy of needs. Maslow proposed that our needs are organized into five categories, running on what I call a ladder from the lowest need to the highest need. The lowest need category consisted of humans' basic needs to support their biological function. You move up the ladder after each need is met. The five needs are:

1. Physiological (the lowest need)

2. Safety

3. Love and belonging

4. Esteem

5. Self-actualization (the highest need)

Some of these needs may be self-explanatory. To meet or fulfill a need, you would have to achieve certain things in the context

of each. Physiological needs are the most essential: food, water, sleep, maintaining a certain body temperature, etc. Safety needs include health, physical safety, and job security. Love and belonging needs relate to your overall well-being, sense of belonging, feeling loved, and feeling love for others. The first element of our need for esteem impacts our wish to feel good about ourselves, and our self-confidence. The second component of the esteem is being acknowledged and recognized for our achievements and being valued by others. Self-actualization involves feeling like you are doing what we were meant to do, what we're born to do—feeling like you were living your purpose.

At this stage in my live, I had no purpose, no meaning. I was unknowingly working on my *suffering* journey. I was exhausted, sleep deprived, and hollow. I felt like a doughnut that someone kept refrying. After years of being retraumatized by triggers, one uneventful day, I was finally ready to get unstuck. There was no epiphany that brought me to this state of readiness. Intuitively, I just knew *something* had to change. *I* needed to change. I was going to figure out a way to stop my emotional eating and suicidal thoughts. Through trial and error, I cautiously attempted to uncover what I needed most to become whole. I slowly learned my ultimate need was directly tied to my most painful wounds. There was no escaping the fact that I had to go *through* my terrifying trauma wounds to heal. I *needed* to heal.

My hodge-podge self-healing actions began. With great hesitation and initial failure, I slowly replaced my addiction to strawberry Haagen Dazs ice cream by filling my fridge and belly with cherries, strawberries, grapes, and mangos. I stopped

suppressing the negative emotions. I poured them into my journal. I cried whenever I needed to release the pressure that was cooking my existence into a kind of putty. This putty was busy working to seal out any hope of healing. I practiced yoga, read self-help books, and recited self-soothing affirmations. I tried therapy but struggled to find the "right" therapist. Through years of self-work, I finally discovered the ultimate battle I was fighting: the battle of self-hate. That was the almost insurmountable trauma wound that I had to heal.

The self-hate battle had me stuck. I hated that I looked exactly like the demon who sexually abused me. I hated that I could not trust my mind by detecting wicked people like my father. I hated that I could not stop bombarding myself with nightmares. I hated that I had to keep moving from city to city to feel physically, emotionally, and spiritually safe. Who was I still running from in that running dream that kept me on the move so much? I was disgusted by that little girl who allowed her father to abuse her sexually. I detested myself for not remembering so much of my childhood, including being abused. I was angry at the little girl who did not tell her mother what her father was doing to her. Then again, why would I have told her back then? Mother would have probably ended up beating me like she always did. I hated feeling like my mother hated me for cutting her life short. I hated the scars that were all over my legs. I hated that my world was so small because I didn't trust anyone, sometimes not even myself. I hated that I couldn't be 'normal.' I hated that I was too weak to hurry up and heal and get my head right. Most of all, I hated myself.

Through self-work, as painful and demanding as it was, I identified and understood my specific physical, emotional, and spiritual needs. For the first time in my life after about a year of beginning the work, I gradually began to see myself! One day, I caught myself smiling for no reason at all. It was a genuine smile, not forced or guardedly delivered to my neighbor as I grabbed my morning paper. This was a fill-my-whole-face, effervescent, cheerful smile that I conceived from my core. That's how I first *saw* myself. I *felt* the wonder of a carefree child. My spirit gave me permission to surrender to a hope that was somewhere on the road where the smile would lead me. I didn't know I was crying until salty droplets skimmed my lips.

I saw myself that day. Not just the shame, the physical and emotional scars, and the face that looked like the monster who sexually abused me, but I saw the possibility of a new version of myself. One that I could create. I now knew what I didn't know that I needed to know. I now knew what I needed. I needed to reprogram the self-hate into something positive. I had seen and felt the positive effects of journaling and the new habits I had created. I could change from being a sour power to becoming a Me-Love-Boogie. I could become someone who liked herself and someone who loved herself. That epiphany lifted my spirits and accelerated my commitment to the daily practice of healing. I needed to stay committed to the work of healing. I needed to love myself. I needed to transform self-hate into self-love. Simple, really. Or was it? My intuition told me that self-love was my freedom.

My affirmation sang out from my spirit:

In gratitude of a new day, I rise to self-compassion. I rise to self-love. I rise to purpose. I rise to freedom!

I would keep that promise to myself—to love myself like my life depended on that love, because it does. I put my affirmation on post-it-notes that I left on every mirror and window in my house. I would keep the affirmation in my car, in my mobile phone, on my fridge door, on my desk, and on my bedside table.

Before I named the ultimate battle that I was fighting, I had already named all my wounds. It took a lot of courage and mental stamina to acknowledge those wounds. I named my wounds to identify what I needed and to understand the changes I had to make to manifest what I needed. I had learned my wounds were the children of the mighty mother that birthed them. The mother, self-hate, was the name of the ultimate battle I was fighting. *I had to* name that battle.

When you name the mother of your wounds, the grandmaster of your wounds, you come to know the identity of what you need to change. If we don't know what we are up against, the battle we are fighting, how can we make a change? Isn't that what we, the survivors, seek? A transformation? Many of you have told me that your greatest wish is to get unstuck. You need to feel whole and get rid of the pain and the shame. You told me you want your wounds to heal, to find inner peace, and to create a new life. You have told me you want to create a new

version of yourself. It starts with you telling yourself the truth, the whole truth. That's how you begin to melt the shackles that have bound you to your biggest battle.

Healing takes grit. Healing is the ultimate investment you could make in yourself. We get mortgages to secure our dream homes, paying hundreds of thousands of dollars over twenty or even thirty years. We even get two jobs and a side hustle to pay off that BMW and luxury vacation. And our healing journey? What are we willing to dedicate?

Journey to Self:

1. Have you identified your emotional, physical, and spiritual needs?
2. How were you able to identify them?
3. What are your emotional, physical, and spiritual needs?
4. Do you judge yourself for needing what you need?
5. Were any of your needs discovered randomly or by accident?
6. Do you have any creative needs?
7. Are any of your needs connected to something you enjoyed when you were a child?
8. Have you communicated your needs to anyone?
9. How do you keep track of your needs?
10. How do you keep track of your progress toward achieving what you need?

What I Have Learned:

Until healing became the destination of my next breath, I remained stuck.

Yes! It had to be that urgent.

Invest in the self-work and the daily habits that only *you* can practice.

Habits that Help my Healing Journey:

1. Repeating my truth, out loud and to myself, is how I melt the shackles of shame.

2. I need a support system to help me heal. (Even if it is your dog or one trusted human, find your support system).

3. I need to know someone I trust holds a physical or emotional space for me where I can feel safe and be held accountable for the actions and mindset required for me to heal.

6

Surrogates

What do you need? What is your plan to get what you need? These are my constant questions. Since I was a child, I understood that I would have to work for whatever I needed. I have always been an overachiever. My family and friends would tell you, Wen gets things done. I would attack a personal goal as if my life depended on it. I had to get it done in the timeframe I had set to get it done. I had to study the process to achieve that goal. What I didn't know, I read about and found an expert or resource that would address my limitations. I was an insomniac, so I had plenty of time.

Until I wrote this book, no one knew that the urgency of my goal achievement hinged on my "in-between-state." This state was the space between experiencing triggers and feeling depressed. You see, I never knew when the trigger would cut my moments of near normalcy into pieces and drag me into feeling hopeless and depressed. My in-between-state was a period of productivity.

I was living in a quaint town in North Carolina for about a year. I had been experiencing a long stretch of lowness. My nine-to-five finance job was unsatisfactory and I decided to quit.

I had no other job lined up. I was a saver and had enough of an emergency fund and investment income to buy some time while I figured out my next move. What was it? I had no clue. I did know that I needed to get away from the super religious people who only tolerated their version of God. The constant travel and perpetual deadlines were not serving my mental health. I needed to be quiet. I needed to calm my mind. My intuition said so, and I trusted it. I told my family I was going off the grid for at least three months. Translation: leave me in peace.

During this sabbatical, I discovered my love of painting. I was no Basquiat or Seurat, but that did not matter. I also read a lot. My old favorites were mystery novels, Iyanla Vanzant, and Eckhart Tolle. I stumbled on Rainer Maria Rilke's book, Letters to a Young Poet. What did I discover? Some people had some of the beliefs I was finding within myself. There are many lessons in Rilke's book. The ones that resonated were the gift of stillness and the rise of your most authentic self. That's my interpretation. I was so inspired after reading that 123-page book that I went on a shopping spree the following day. I purchased a keyboard, a keyboard stand, an amplifier, sheet music, a mixer, a microphone, a mic stand, cables and wires, a MacBook pro, and music recording software. My intuition told me something was coming. A few nights later it arrived.

I was asleep. I heard trumpets. Then the remainder of the song presented itself fully formed—French horns, bass guitar, djembe, violins, piano and keyboard, melody and lyrics!! I was inside the piano's action. The downbeat had me swaying and singing into the instrumental chorus. Hanging onto the suspended fifth, the

violins finally let go. The piano tentatively slid into the pocket with a graceful minuet. Then I returned singing:

"I don't know what will I do! I don't know!"
"I don't know what will I do-oh-oh-oh I don't know."
I had written my song, "Treasure."

I had similar experiences years before, but not like this. When I was a child, I would get random melodies in my sleep and write songs. The first song I wrote was called "Johnny." I wished for a baby brother. I used to sing it to my mother and mother's friend Cecilia all the time. A few years later my brother Dusty was born. His birth is still the happiest day of my life.

What was different about this song, "Treasure," is that the whole scope of production came in my dream. The instruments' arrangements were crystal clear. I worked out the chords I was hearing, wrote the parts, including the vocal melody and the lyrics I heard. I did not have much work to do.

Other songs came as well, including "Woman Empowered." That song was like a freedom march. It was a proclamation of the empowerment of Wen. I had found my Voice and the courage to use it. The second verse was about my fight to free myself from the bondage of shame of being sexually abused by my father:

"Been under your thumb for so long
Forever writing this song
Don't want to be defined by you, you see

Got to reclaim my dignity
Every other woman should confess. The feeling, hmm
the feeling
Every other woman should not deny
The burning, yearning. Yeah!
If I should step out this here
Would do any damn thing I dare!
Aaaaah! No combing my hair.
Go swimming in the bare.
Just wanna be free. Just wanna be free.
Free to be
Empowered
Woman! Empowered!"

The music, the songs, and the feeling of self-love did not fall from the sky like manna from heaven. They were hard-fought. It's no small feat that I could touch the source of healing they bestowed. I connected with my spirit through my healing journey. Through that connection, I realized that my soul had the mighty power to direct the orchestra that was my life; my mind, my body, and my spirit itself. The song that brought this mental clarity was called "Raise that Head."

It was early fall. At two in the afternoon, I was driving through a tunnel of cool breeze on a Virginia highway. North Carolina, home, was over three hundred miles away. I had been feeling depressed since before my birthday, six months earlier. For years I never celebrated my birthday. I never got the point. Why

commemorate a union and product that brought me dread? As an adult, that's how I had come to regard my birthday. I had been driving back from a trip to New York. There was not much traffic on the highway. It was a beautiful Sunday, but its beauty was lost on me. I had driven this stretch of highway many times. I used to like the view of the rainbow-colored leaves. I used to enjoy the whiff of rosemary pine burrowing through my Honda's moonroof.

Four years and three months into my *suffering* journey, I was down deep in darkness. I had started seeing a new therapist after I moved to a smaller city in North Carolina. I didn't like her. She was pushing me to take antidepressants. Every visit she would say:

> Psychiatrist: "Have you given any more thought to taking XYZ to help with your PTSD?"
>
> Wen: "You mean the one that would make me feel numb, become a diabetic, gain weight, and make me feel suicidal? Those ones?"
>
> Psychiatrist: "I would be monitoring you and you may not have to use them for very long."
>
> Wen: "No, again. I don't want pills to control my life."

I had not seen her in two months. I thought she was lazy and wanted to get a kickback from the pharmaceutical manufacturers. This new therapist did not want to do the work. *I mean, why else was she being so heavy-handed with the "take-the-pills-routine"? During the last five sessions that's all I had heard. Why couldn't she DO something else to help me?*

As I watched the trees ahead, it was as if their palms of leaves were beckoning me. In my mind I saw myself flying over a small bridge that was coming up not too far ahead. The bridge was more like a clutter of sprawled forearms hiding the river's warm greeting. I thought, *I could turn my car to the right and surrender to the water's decision.*

At 2:45 p.m., I reached to turn on the car radio in an attempt to distract myself from the suicidal thought, but changed my mind midway. I was so weary. The hopelessness, helplessness, and darkness had reclaimed me. I had tried this before, ending my life. The fistful of pills I took in my New York apartment did not live up to their expectations. This vault was to be my salvation. The river below would drink in my depression and put it to use. My depression would decompose the river rocks and, after a while, create sand. The sand would fill the beaches and oceans that tickled me as a child. Maybe in this form, sand, I could help a girl somewhere, build hope.

I was ready to escape the betrayal called life.

My therapists couldn't drain the trauma from my mind. And I couldn't fix myself. Inside, the negative self-talk circled like vultures. They ratted me out. They foretold the tale of my donated carcass. The gas pedal heard the sentencing. I began accelerating. Sixty-five miles an hour, seventy, eighty, ninety. At ninety-six miles, I heard The Voice.

"Come back to me."

It was an unrushed whisper that seemed to change course to find me. The soft spot on the top of my head prickled. A shiver

spread through my body like fever. I was choking on air. Startled, panicking, and confused, I shouted. "Who was saying that?"

"Come back to me," I heard again.

I was like a meerkat, alternating the gears of my neck pursuing that Voice and leery of anything that could have created the sound; my cell phone, the radio, anything? My head sprung to the right, suspiciously scanning the passenger seat. Rebounding from the shock of the empty space, I eyed the hitchhiking trees. Glaring at the backseat through the rearview mirror, my eyes were hunting the bearer of those words. *No one was there? No one was there! What in the hell is going on? Am I speaking? No? Did I butt-dial? I'm losing my mind! Is there a ghost in the car?* I was alone. I was trapped. Then I heard the Voice again.

"Come back to me."

I must be hallucinating! "Arrrrrrrrrrrrh! Stop it! STOP! IT!" I screamed. *I am losing my mind.*

The Voice, soft yet persistent, overpowered time and put it to sleep.

A low moaning came from somewhere inside me. It turned itself into guttural cries, it crumbled, creating a thick jowl. I barely noticed my new feature. You see, the Voice was inside the car and inside my head. The Voice was under my feet and outside the car, everywhere. It was as if I were driving inside the sound of the Voice that belonged to no one. Sour bile collected in my throat, concentrating on the fear it was secreting. I was becoming disoriented. My vertigo started to kick in once more. Trying to ground myself, I gripped the steering wheel as hard as

I could. My fingernails were cutting my palm. I closed my eyes like I had done when I left *that* Bruce Willis movie to drown out the spinning. Driving, my eyes were closed.

I was jolted by a bazaar phenomenon. The Voice. It had its own pulse. It disengaged me from Virginia and her highway. The Voice unlatched me from my depression and my seat belt. I felt suspended above the car seat. Under the wing beat of the cocooning Voice, I was spellbound. The negative self-talk recoiled like a reverse pirouette, conceding to the Voice. Now unguarded, I was defenseless. There was just me and the Voice. I felt wobbly, yet underneath that tremor was a newborn feeling. A vibrating awareness. The Voice gave the awareness its own frequency and mission. It was undemanding, like the socks I wore to bed on snowy winter nights. Slowly, I was being righted. Unsure of what was happening, the anxiety made my left eye twitch. Nervously, I peeked from under the lids to see what was before me.

The sun was still shining around me, the trees were still there, but the bridge was gone. It was behind me. What felt like hours happened in minutes. It was 2:47 p.m., according to the car radio. I felt slowed, like my car. I had taken my foot off the gas at some point, now going sixty-three miles per hour. Gracefully, a wide, airy peacefulness emanated from my spirit. It built my next breath and the ones that followed into a relaxed adagio. My shoulders unpinned themselves from my ear lobes.

The Voice: "Come back to me."

I sighed into an overdue smile that skipped into a chuckle. *This must be how butterflies feel climbing the arches of the sun!* I knew there was a higher power at work here and I accepted it. With this balm and its knowing, I felt protected. The shackles of shame, fear, and self-hate melted away. I felt loved. My body, mind, and spirit were riding the cascading joy. After thirty-plus years on earth, my heart felt unbroken. I was love-powered.

I had experienced a *spiritual awakening*. I did not need any explanation. In my culture, these events were not uncommon. For the people of my country when I was growing up there, your spirit is the line of sight you trusted, if you could tap into that part of yourself.

I would not say I was a religious person, but I knew intuitively there was a higher power at work on that Virginia highway. Call it God, Buddha, or whatever you want. I knew that power existed. I didn't need science, a pastor, or a bible to tell me that. In the car that afternoon in Virginia, some force pleaded with me not to take the plunge. The force was gradually peeling the negative thoughts away, so that I could hear and feel the shelter of love. I kept resisting, but I was being enveloped by love, love from a power higher than anyone I have ever known, and love for myself.

The car slowed even further. Overwhelmed and overcome by gratitude, I pulled the car over after passing the bridge. I cried with my head on the steering wheel, long tears of the old pain and the fresh hope I had received that day.

On that day, my suffering journey ended and my *healing journey began*. I was ready to heal.

I drove home and wrote the song, "Raise That Head."

"I was down
So low couldn't find myself
In between
Tried to erase myself
See I believed no way,
no how can free memories, they bind me
Then I heard
Come back to me
A voice said
Come back to me
Raise that head
Come back to me
You are mine, my child
Come back to me."

About four years later, I put on a micro-tour with my band to support my self-produced debut album, Woman Empowered. Those songs became a ten-song full-length album, sold under the moniker Wendy St. Kitts. I found a part of myself that was not sullied by my childhood trauma. It was my spirit.

Through spiritual awakening and self-work, I found my surrogate parents. I learned to reparent myself. My unflinching desire was to not become my parents; to not develop their devastatingly harmful characteristics. My parents did not meet the intrinsic needs I had as a child. They passed on their unresolved trauma bonds to me. My parents refused to acknowledge the

childhood trauma they suffered and the fresh wounds they created in me and in themselves when they abused me. The hurt they received during their childhood and life experiences they gave to me. That was my generational inheritance.

My very first step to reparenting myself was to not inflict additional trauma onto myself. I put a tremendous amount of pressure on myself to excel professionally and to help my friends and family, providing comfort, time, and energy. I was my worst critic.

Over the years, I learned how to let the feelings of self-love transmitted during Virginia's awakening settle and become part of my being. It began with getting rest. I was an insomniac, so getting more than a few hours of sleep seemed unachievable. For many years, I used sleeping aids to help me sleep, no more than two pills, because my mission was now to rest, restore, and recover—not suicide. I created daily self-care and self-love habits that focused on my inner life.

I started each day by not jumping out of bed and hastily getting ready for work. Thanks to my internal island-life clock, I got up around 5:30 a.m. every day. That was four hours before I had to be at work. I encouraged myself to stay in bed and to unswaddle tenderly. I would allow my spirit and my body to reconnect naturally. I did not rush my awareness of the day. I didn't open my eyes and grab my cell phone. No.

With my eyes closed, I stayed still and listened to the morning as it stretched. I would imagine the dew on the flowers and the grass and how welcoming the sand would be. Nature always

makes me peaceful and playful. Then I would imagine me and little Wen living our dream life. This life was filled with inner peace, love, laughter, music, spiritual, mental, and financial freedom, sharing and helping survivors and playing in the oceans of the world. Gently, I would open my eyes and recite positive affirmations, or just say "thank you." I was grateful a new day had given me a chance to earn a breath, or two or three. I would then reach for my journal and write at least five things I was grateful for. It always began with rest.

Then I attended to my awake life. Changing my diet of ice cream Friday nights to fruit-filled Friday changed my gut health. There were no more stomach pains and bloated feelings. Plus, my cholesterol thanked me. I started walking and weight training.

I prepared for bed at least two hours before I needed to be asleep. I had a spa-like nightly shower; soft music, candles, body wash, Japanese exfoliating body towel, and a moisturizing butter to love-up my body scars.

This night routine calms my mind and signals the glory of rest is on its way. As a child we were poor and did not have cable until middle school. I am not a television-show-watching person. I find it boring and a time waster ninety percent of the time. So, before going to sleep, I would read something that would not busy my mind. The exercise fatigued my body. The healthy eating made my stomach and bowels happy. The nighttime routine was my "let me love you Wen" sanctuary. After about one month of this routine, I gained an extra hour of sleep; from three hours to four

hours of uninterrupted rest. What a celebration! Uninterrupted peaceful sleep and mind are invaluable.

With this slow gear living and self-love mindset, I became less judgmental. If things did not go as planned, if I failed to complete a task or if a relationship ended, I told myself, "Receive the lesson. Failure helps the learning to stick."

I empowered myself to recognize that these experiences were all my teachers, helping me to build a compassionate and resilient muscle within my mind.

Next, I focused on my temperament, my thoughts, reactions, and behaviors. My parents were emotionally immature and violent, as reflected in the physical and sexual abuse they put upon me. Even as an adult I witness their defensiveness, temper tantrums, denials, and reputation preservation. Their ego and prideful ways are impenetrable. To combat this forecasted inheritance, I studied myself without judgment or correction. I wrote down what was happening internally when I experienced conflicting emotions and circumstances; anger, frustration, happiness, sadness, depression, anxiety, betrayal, hunger, love, etc.

Over many years in my healing journey, I learned to accept that people showed me *their* life story, character, and values when they hurt me. To that lesson, I learned to say, "Let the teachers teach"

I could either receive the lesson or repeat the pain. I did not have to accept their disrespect of my values. I did not have to join the petty tit for tat that children often do.

I learned that I needed to regulate my emotions by focusing on my temperament. I had to "bench" my ego. Just as I had

slowed down my sleep life and awake life, I had to slow down my active hours. I trained myself, over many years, to not take things personally when people were unkind to me. That meanness had nothing to do with me. It was their insecurity, hurt, and baggage, not mine. I would not carry their load, for mine alone was buckling my gait. For example, I used to get heated when road-ragers cut me off in traffic. With my temperament shift, I take a long, slow breath, shake my head and think. I learned that leaving the environmental source of negative emotions was beneficial even for ten minutes. This is trying and requires a lot of patience and practice.

Next, I focused on my safety—physical, psychological, and spiritual. I did not feel safe being a child. As a girl, I relied on my parents for physical, emotional, and spiritual nourishment. In my father's case, he is a terrorist of the body, mind, and spirit. He made me a woman earlier than eight years old. My mother warred with her lost dreams, inability to navigate conflict, and unaddressed trauma every time she whipped me. Her words were often more destructive than the pummeling. She was trying to control my nature as an independent thinking child.

From studying myself, I learned I needed to live in a safe, quiet neighborhood and limit my exposure to controlling, narcissistic, and manipulative persons. I reduced my already small circle of acquaintances and friends. I also learned to trust my intuition when red flags were noted in a person's character or in my physical space.

In connecting with my spirit, I was given the love and care that I could not get from my parents as a child. I developed

daily self-love practices. I learned how to dial down the stressors, defuse the triggers, and be kind to myself.

With this spiritual awakening, I made a promise to myself. I would listen to my inner Voice and work hard to trust my intuition. I had to trust my intuition and attend to my needs first. Listening to my inner Voice was how I survived, became emotionally mature, and continued my healing journey.

Creating boundaries allowed me to be my most authentic self. I created boundaries to protect myself from harmful people, environments, and experiences. My boundaries were physical, emotional, and spiritual. They are my surrogate parents.

I recognized that I needed and valued Wen more than anything or anyone. I communicated my boundaries in simple language to all people in my life and the people I encountered. My boundaries help me create a safe emotional, physical, and spiritual space.

My first surrogate parent is the physical boundary I established. I left St Kitts. I did not even regard the move as boundary-setting back then. It was my way to find my way in the world. Was my migration primarily to pursue a higher education? No! I separated myself from the source of my physical abuse. Protecting my physical space created a haven for me to thrive, mentally, emotionally, and spiritually. I am very selective about who I invite into my world (via phone, email, etc.) and who I allow into my home. Just because we may be related by blood does not guarantee an invitation.

My second surrogate parent is my spiritual boundary. I trust my intuition. If my intuition tells me that someone is

filled with negativity, I listen. If I interact with someone and I feel drained of energy, I listen. Through self-work, I know that my reservoir of positivity can be hard to maintain at times. I don't need any "Dana-Downers" to help me feel depressed. To preserve my overall well-being, I communicate my mental needs and remove myself from those relationships if the relationships do not support my healing.

My emotional boundary is my third surrogate parent. I set emotional boundaries within myself. I communicated what I needed to myself from myself. I held myself accountable to those boundaries. There was no leeway. I needed a peaceful inner life. To get there, I needed to spend my time in stillness, meditating, yoga, enjoying nature, and loving myself and all my flaws. I stopped judging myself so harshly. I invited gratitude into my life. For example, my nose is my father's nose. I used to hate my nose. Now I love my nose. Why? It helps me to breathe. Breathing is not to be underestimated. So, I am grateful.

One essential step toward healing was setting emotional boundaries for my family and communicating those boundaries. For example, if a family member continued to repeat behaviors that were harmful to my mental health and safety, I expressed that it was unhealthy for my well-being. Strike one. If the behavior occurred again, strike two. I then removed myself from their lives. That may seem harsh and selfish. This is how I protect my mental health. It is sacred. I am not living my life for my parents, friends, mentors, or partners. I am living my authentic life for me. I have earned it. I deserve it. *I will have my peace.*

In my family, there were limits. You were born with limitations. You were limited by the examples of your family members' lives and choices. The consensus back then was that you go to high school and get good grades. When you graduate, find a bank, hotel, or government job. You live with your parents and support your parents financially and emotionally. I first became aware of this as a girl when I saw the patterns inside my family and village. I knew that was not going to be my life. I had dreams.

What did I do? I broke the damn cycle. I got sick and tired of trying to be the daughter my mother wanted so that she could parade me to her friends. I was done with having an unhealthy relationship with myself to please the people in my life. No. More. Some call me selfish, ungrateful, they say I have "changed." Those descriptors are not my responsibility. My responsibility is to my healing and mental well-being.

My energy, time, and heart are precious. I sharpened my awareness of who I was and what I needed. I needed FREEDOM! I needed to be my truest self, to tell my entire truth and care much less about people's perceptions of what I was to be for them. I was ready to fall and be in love with my whole self.

I fully accept that I was abused. I fully admit that I am an independent thinker that will absolutely pursue my dreams. I do not seek, need, or want anyone's permission to soar. I will use fear and turn it into fuel. I have nothing to lose. I have survived sexual abuse, physical abuse, suicide, depression, anxiety, isolation, shaming, and rejection. I have *nothing* to lose.

We are human beings with desires and longings. I have learned my craving for ice cream was attached to my emotional history of abuse. The ice cream was a surrogate parent. You will need all the strength to heal your inner child and may not have time or energy to give yourself. Loving and caring for ourselves must be our number one priority. If we didn't prioritize this, we would not have survived the abuse. We would still struggle to heal our wounds.

We must be brave enough to study our emotional history. We must be brave enough to open those wounds and listen to what we need. Your children and friends cannot fix you. Do you trust the partner who may be suffering from their childhood trauma to take up your load too? They are often part of your emotional history. We may expect the people in our lives to make us whole. They cannot. That's your work. That's my work.

Journey to Self:

Some of the boundaries I need and will keep:

1. I can love you and keep you out of my life if you are harmful to my mental health.

2. Adults, including parents, do not automatically deserve respect. They earn it, action by action.

3. I will not apologize for my values of self-love, self-respect, and living an authentic life.

4. I will not apologize because you are uncomfortable with my values.

5. I will not call, email, text, or discuss my ex. Although I miss him, I need to clear the way for the love of my life.

6. I said NO. I do not need to explain myself.

7. I am a morning person and use that high-energy window to practice healthy spiritual and mental habits. I love you, but no, you are not invited. This is my sacred time.

8. I will tell you and show you what I need. You are not required to do anything you do not wish to do. Your permission is not required to define my worth. That is my responsibility.

What I have learned:

1. Self-pity can feel like a hug. It may be our only source of comfort and a shelter for our truth. In cultures and families that often invalidate, dismiss, and even mock the horrors of our abuse, we may be the only person we have to soothe away the hurt.

2. It is okay to have empathy for ourselves and the dreadful tragedies we faced, replacing the compassionate support system we desperately need.

3. Self-pity excels at focusing on our hardships, sorrows, and darkest parts. It keeps us laser-focused on the hurt. It leads to self-absorption that becomes fat on our isolation, depression, anxiety, self-hate, and low self-esteem.

4. Prolonged self-pity spreads the suffering created by our past into our now and prophesies our future. It causes more dwelling on the negative and the impossibility of hope, of healing.

5. Self-pity can be harmful. It can control our entire lives and keep us stuck.

Habits that Help my Healing Journey:

I am grateful for and need a supportive and trustworthy person/support system who:

- Listens
- Allows me to be seen and heard
- Asks, "How can I help?"
- Says, "Vent if you want to?"
- Sits with me
- Says, "I can't imagine how you feel and what you've been through."
- Checks in on me (calls, text, etc.)
- Respects me

7

Come Into My Heart

What would happen if you felt calm inside? What would happen if you felt as light as a petal? What would happen if you touched your dreams? What would happen if you kept your promise to yourself?

My maternal grandmother's name was Winifred. Her great-grandmother was a slave from West Africa. Her name was Yaya. Transported like cattle from the motherland, Yaya found herself six thousand and four hundred miles away in St. Kitts. My auntie Ket told me she visited Yaya many times when she was a girl. My aunt said that Yaya hardly spoke a word during every visit. Auntie Ket said Yaya would keep "looking out." She would stand in the doorway of her tiny wooden house, "looking out." It was as if she was searching for something. As Yaya traced the flamboyant trees, inhaled the sugar cane breeze, and listened to the melody of the goats and mischievous monkeys, where did she go? In her one-hundred-year search, did she find what she was looking for? Yaya died in 1953.

Yaya was traumatized. Yaya was abused. Pain became her name. Silence was her sanctuary and her slave ship. Before she became herself, she was somebody else's property.

Yaya may have left that slave ship, but in her mind she was still enslaved by the trauma that consumed her existence. Sometimes, like Yaya, we are stitched tightly in the trauma bond. Sometimes we just want to lay down and die because it cannot get any worse than the emptiness and the lowness we feel, right? Here's what you may not realize and what took me a long time to learn. If you survived childhood sexual abuse, you have already proclaimed yourself as a resilient warrior. You don't believe me? Let me show you.

The fight that you may or may not know you had inside brought you to adulthood. Feel what I am telling you, my sisters and brothers who were discarded and left for dead by the demented, wicked abusers. Deep inside of you, somewhere along this big bad battle to free yourself from the trauma and the bondage of shame, *you did not give up on yourself.*

We were like slaves to our abusers. Our fragile minds and trusting nature empowered them to hurt us again and again. We can take back our power! We must take back our voice! Are you looking for inspiration, motivation, and an example of resilience? Look in that mirror of yours and say to yourself:

I am worthy of becoming my dreams!
I am inner peace!
I am self-love.
I am beautifully made.

My brothers and sisters, I see you. I feel you. I am with you. We all need a little fellowship. Sharing is why we are here.

Let us "power-up together." We can introduce the world to the new WE.

First, you have to meet yourself, your empowered self. How do we become empowered? We accept all our parts, the good, bad, and horrible. How do we become the weaver of our dreams? We get off the mental slave ship. We drop the shame. Our minds cannot be auctioned off by unhappiness, unfulfilling relationships, or emptiness. No! How do we heal childhood trauma wounds? We get busy doing the work of loving ourselves as if our lives depend on it. We actively seek *mental wealth*. Netflix will be there in the morning. You need your undivided attention, for even ten minutes per day. What a difference those ten minutes will make. I have been to several psychologists, therapists, and psychiatrists. I am grateful for what I learned from treatment, but up to this point, I could not find the "right" therapist who was willing to help me figure out the treatment that would dethrone the self-hate and shame. So, I had to do the work.

None of us could ever fathom the life my grandmother Yaya and maybe your people have endured. No one will ever fully understand what it is like to have been abused or traumatized as a child or even as an adult. I said it plainly in this book. When my memories of being sexually abused by my father returned, I hated myself. I detested every inch of my body and my mind. I had the face of the terrorist who molested and enslaved my mind. I was an offspring of that demon. All I saw were flaws. I remembered making a list and telling my cousin Deidrea that

I counted 123 physical flaws. I was depressed for two weeks after that count. There was no way I was going to count my internal flaws.

Like me, you may have received the inheritance of silence, shame, agony, and hopelessness. You have lived so low you cannot even find yourself. Where do we go from here? We can only rise up. How do you rise?

During the period of childhood abuse and trauma, I had some good and horrible days. My brother Dusty was born. I was eleven years old when he was born. That day is still the happiest day of my life. My mother gave me the brother that I was begging her for. I could never hate my mother. I could not erase the blue (painful) parts of my childhood because I would have to erase the orange (happy) parts.

The blue parts of me represented grief and sadness; the whipped girl; the girl disconnected who hurt her cousin Deidrea. Orange parts reflected joy, lightness, and playfulness. It has always been my favorite color. I have always had an acute awareness of color and the emotions they evoke. It was almost as if I could taste them. My sensitivity to colors stemmed from my childhood in St. Kitts. I believe this sensitivity was developed from the color of the clothes my father wore when he sexually abused me.

Poly mangos, from nearby Nevis, my favorite mangos, *always* exploded with the juiciest plump orange goodness with every bite. Pumpkins were orange on the inside. I loved pumpkin in my soup and with the steamed fish my mother used to make.

Ripe puupoys (papayas) were orange on the insides too. There were no blue fruits in my country.

I had to accept both the blue and the orange children. I learned I had to spend as much time loving up the blue children through my self-work. I had to love my blue children with my whole heart. I had to love them unconditionally if I wanted to heal myself.

I call them my children because that is who they are. They were with me when I was a child and now an adult. I am an adult, but those parts of me are still children, developing. Those parts of me that were stuck at the age I was abused. They were the children stuck in my repressed memories. All they have ever known is shame, pain, and hate. They need me as much as I need them. I am their mother. It is my responsibility to heal them. I love them equally. Come into my heart. I had to accept all that has made me Wen.

I could not throw away my fears and my baggage and get on with my life. Being afraid was my life. Being afraid gave me information about myself. Fear helped me clarify and be specific about what I needed to create a new version of Wen. I couldn't cut off my leg to rid myself of the spots on my skin. My legs, with all their scars, are a part of me. These two legs gave me the ability to run, walk, swim, and be one with nature. Understanding what I was fearful of was vital to my healing journey. I would not have created RebelForASpell if my life had been full of 'normal' highs and lows. The shame, sadness, and struggles to overcome childhood trauma and abuse shaped the

woman I am. I love the person that I am. I could not truly love myself until I told myself the truth about my whys.

I will not lie to you. Healing yourself is a painful business. Do you hear me? Healing childhood wounds is not a makeup tutorial. There is no instant gratification. What is the value of your life? Time? Energy? Money? What is the difference between taking out a thirty-year, $100,000+ mortgage and investing in your healing journey? Why do one and not the other?

For some of us, it is easier to spend thirty years paying off a mortgage so that we have a place to live when we retire, or a place to raise a family. For some of us, we decide to spend thirty years healing our inner house of childhood trauma wounds. But if we buy that physical house and never heal our inner house, then that inner house, with all its trauma rooms, moves in with us after we take up residence in the newly purchased physical house. Our inner house is with us in every dwelling in which we live. It cannot be unhinged.

Here's the thing about healing. It boils down to giving yourself true love. That is what healing childhood wounds is about—lifelong movements of self-love. After being whipped by your trauma, trashed by triggers, and hated by yourself, isn't it time to fill yourself with true time, love, and patient grace?

I was healing. My life was changing. I was transforming. By creating a new version of Wen, I was protecting myself from self-harm and protecting my present and future relationships from that harm. My present day looked very different from some years before. It had been over eight years since I asked my

mother to apologize for the brutal whippings and she said, "Look how good you turned out." Two years before this conversation, I told my mother about my memories of being sexually abused by my father, the terrorist. When confronted with my truth, my father said I made up stories about him. At this stage of my healing journey, I accepted my parents will continue to deny and dismiss the suffering they inflicted upon me.

My mother and father were the holders of many facts that they denied or dismissed. My parents refused to take responsibility for their actions. They are prideful egomaniacs who are going to protect themselves, regardless of the carnage they caused. Neither what my father nor my mother said invalidated the pain and the suffering they caused. In a way, I used their betrayal as rocket fuel to accelerate my purpose. My parents gave me the inheritance of trauma. There was nothing else that I wanted or needed from them. My life was in my hands.

As children, when you are raised in a dysfunctional environment or have emotionally immature guardians, you shadow their behaviors. We see the weapons of immaturity regularly used, the silent treatment, door slamming, brutal beatings, shouting, and name-calling. We see these examples of an "adult" behavior and follow that pattern. Soon, this becomes our generational inheritance.

As I healed myself from the effects of childhood trauma and abuse, I identified all that I needed, from myself, my relationships, and my environment. This mental clarity gave me the confidence to ask for what I needed. I required emotional maturity and clear communication. I found my voice, and I used

it. From myself, I demanded a healthy mind, body, and spirit. I needed a life of abundance filled with inner peace, self-love, and freedom. Damn it, that life was to be mine.

In those initial years of healing, I *went along to get by* in my professional life. Here's an example. When I lived in North Carolina where I worked the finance job with uber religious coworkers, communication was a huge challenge. What I am about to share transpired during the second or third year of my *suffering* journey. In this department at this new job, I was the new kid on the block—the black twenty-something from somewhere other than America. I did not know the shorthand terminologies the team used. I would go to meetings and detach myself. I would get lost in the *this is what we are going to do* presentations, and get frustrated from trying to translate what I was hearing. So, I disconnected in the same way I did when my cousin Deidrea called me out to play and I ignored her. I could hear and see what was before me, but it was not resonating.

After the meetings, I would ask my work "friend" to explain the assignment. Of course, something got lost in translation and reflected in my work product. During this stage of my *suffering* journey, I lacked the confidence to speak up for myself. In a room full of humans without vaginas and breasts who were 100 shades away from my mahogany skin and who sounded nothing like me, I was intimidated.

My immigrant female status felt like a menopausal hot flash.

I was different. I was an outsider. This *particular* southern drawl made the words sound like the speakers were rolling their

tongues over taffy. I was scared and embarrassed to say "I do not understand your words," or "Can you simplify the instructions."

Later in my *healing* journey, communication in my professional life improved. The Virginia awakening gave me another shot at life. When a work challenge presented itself, I asked myself, *what will you bring into this world that you have not brought so far?*

If my work colleague or boss gave unclear instructions or were displeased with me for whatever reason, I asked for clarification. I asked them to "walk through" the disconnected parts of the conversation or instructions. What was I doing? I was holding everyone accountable for their part of the communication. I was not going to betray myself and encourage the misconception that I was "slow." Communication is a two-way street. Positions of power do not give anyone immunity from communicating their needs and expectations and listening to the recipient of that information. The use of short-hand codes like "do the same steps you did last time" or "turn in the project when it's in good shape" would no longer cut it. No, not for Wen.

My personal life was also improving. I had left America for several years. Three countries later, I returned to the U.S. It felt like a fresh start. My confidence was growing, and my life was less stressful. I was still working in finance but this time my career was fulfilling. I was settling in a new city and into my identity as a resilient Gladiator of Healing. My trauma wounds were still with me, but "the work" of my daily healing was working! While I was living outside of America, I continued practicing the exercises laid out in this book. After about six months in

the new city, I found a new therapist who was very patient, authentic, and dialed in to my healing needs. This support system was like a judgment free shoulder that I could lean on.

I remember filling my journal with pages of the question I kept asking myself. *What do you need?* So far, I had two definite answers and three maybes. *One of the things I needed was a partner.* So, me and my newly curated confidence joined an online dating site. I went on a few dates with a man who, "on paper," appeared to have it all. He was a lawyer, attractive, and charming. On my profile, I stated I was only interested in monogamous relationships. His profile said the same. On our first date, I asked him questions to learn more about his character. A sexy buff body is lovely to look at and fantasize about during masturbation, but I needed more. I needed to observe his reactions as he responded. I knew dating sites had liars as well as gems.

> Wen: "I joined the site to connect with a man with similar intentions and values. I am only interested in having a monogamous relationship. How do you feel about monogamy?"
> Lawyer: "Well, arrrrm, I think I, arrrm, could be ready for a monogamous relationship."
> Wen: "Really? When was your last monogamous relationship?"
> Lawyer: "Thirteen years ago."

My dear readers, I think you know how that date ended. If you are in doubt, I told him we were not on the same path. I wished

him well, and we parted ways. I learned to listen to what I was being told, not what I wanted or hoped to hear.

My healing journey was in bloom in this new city. The more emotionally mature I became, the more I began to speak up for myself. Spiritually, I was vibrating all the shades of cheerful, hopeful oranges. My self-esteem was growing. I was optimistic about my future. I was happy. I was ready to share this new part of me that I discovered. The more emotionally mature I became, the more safe I felt physically, emotionally, and spiritually. I allowed myself to become vulnerable and to let people into my inner world. I started trusting.

I started to trust myself to make decisions that my intuition told me were *right* for me. In my suffering journey I would often second guess my decisions. As I progressed in my healing journey, I found many of my *intuitive* decisions made my life lighter, more peaceful. For example, I had been saving money for a few years and knew I should not tie up that money in any long-term investments. I knew I would need it. I did not know what I would do but I knew that money had a purpose. One day, I took a wrong turn coming from the beach, and there it was. My dream home.

Me, the woman with the ten-year nightmare of being chased in the night. Me, the woman who couldn't live in a city for more than two years was ready for stability? Yes. I was ready to plant roots. You see, until *we are ready* to do a thing, it will *never* be done. I was ready to commit to building a life that would be in service of my healing—body, mind, spirit, and

heart. Heart? Why this new addition to my healing philosophy? I was beginning to fall in love with Wen.

I had given myself the authority to set up my future self. I had begun to activate my dream life.

I was not looking to buy a house at all. Consciously, I was not even thinking about purchasing. I liked my new apartment. My intuition was strengthening with all my self-work and therapy. It said, *Get your house!*

Within two hours I researched the community and the history of the house. I found a buyer's real estate agent and that evening I toured the house. It was being renovated. There was no electricity. We used our phones' flashlights as we walked through the house. After the tour, I put in an offer. I have never regretted that purchase. I trusted my intuition, my decisions. I was living in my dream home. Who was this new person?

This was the woman who had survived sexual abuse, physical abuse, and suicide attempts; a woman who had earned this moment. I was a woman who was reaping the rewards of years of hard-fought self-work, of practicing and committing to my healing exercises.

I felt like I had come to a bend in the road of my life. As I turned the corner, there she was! The future me. Coming toward me, glimmering like a new galaxy. Future Wen had an aura that said, "I am happily in motion. I am truth and freedom, living strongly in my sense of self and purpose."

She looked at me, smiling with her entire body. Looking into her eyes, I *felt* the warmth of a trusted friend. I giggled as

if I *knew* her route and I had intentionally walked that way so that I could bump into her. Future Wen nodded twice at me. Without skipping a beat, she kept moving on. With that nod and her energy, future Wen had given me her approval.

My life was climbing the Himalayas. I was out of the valley and heading upwards, growing, believing, and *feeling my healing*. I felt secure inside my lungs, my bones, my spirit, and my mind. The triggers had subsided. The running nightmares were less frequent. The boundaries I set to protect myself were working! I felt physically safe in this new city. I felt confident at my new job. I was so grateful to be at this stage of my healing journey.

Up to this point there were three people in the world I trusted. *No, my parents were not in this pool.* Soon there were five. I was making deep connections with some ladies in this new city who shared my values. They were sincere, kind, smart and funny, and working on themselves. Wholeheartedly, I trusted myself and my intuition. Why? I had earned that trust and proved that I was worthy of it. I had been taking care of myself and was working hard to save my life and heal.

In this new city, while I was creating this new version of myself, my intuition said, *Go get your man!*

I was building emotional intimacy in my personal relationships and readily expressed what I needed. The quality of my friendships and my love life improved.

My femininity and sexuality were blossoming. After remembering being sexually abused by my father, I was uninterested in sex. I was celibate for many years. I had sexually intimate

relationships before the return of my devastating memories. I enjoyed emotional intimacy and sharing my life with my partners. But I had not found a partner with whom I could truly let go and be comfortable sexually. And yet, there was comfort and companionship.

Most women didn't know we could ask for what we needed sexually in my culture. We wait for the men to decide how they would like to be satisfied and the domes of their satisfaction. In my family, no one discussed masturbation. There was hardly any talk of menstruation. The female body was taboo, even among women. Even some of my friends from different races, ethnicities, and countries have never looked at their naked bodies.

I kept scribbling in my journal again and again asking myself, what do you need? I have asked this question in different ways throughout this book. On my healing journey, I had to reconnect with my body. It was the trauma body I once hated. This body was now the temple of a warrior. How did it become my temple? It started in New York. I would go on a hunt in every borough trying to find homeopathic remedies. I remember going to a well-known dermatologist in Manhattan, Doctor Z, to get the "latest remedy"—lasers and creams, etc. What a money waster!

In France, I found a potent cream. This fade cream was not in a rush. *But it worked!* It did not bleach me pink, like that lumpy paste the woman in the Bronx sold me. My mahogany was intact, but my scars were fading consistently and gradually. I learned that my skin needed years to undo the damage of the

traveling whippings. Then the spots started to fade! What a glory! My body confidence started to grow.

While I was on my scar healing journey, I began to invite my full face into view. Through this sight, I grew to accept that although my nose appeared to be my father's nose, it was not. It was mine. It was giving me breath. I was not him. I could never be that monster. I learned to reframe the way I interpreted my body. My spottycolonious legs and the face that looked like my abusive father were my teachers and my life guides. They were teaching me acceptance and resilience. They were showing and teaching me the power of transformation. My scars were fading, my eyes were smiling and I was invigorated by the Voice that said "Come back to Me."

My body provided nourishment and strength. It supported my spiritual and emotional maturity. It was time to love the body I had hated for so long. I was a woman with female parts. I wanted to get to know those parts. I inspected every aspect of my body that I could see. I was removing the last bondages of shame that I had. My body was not dirty. My breasts, vagina, vulva, and clitoris are not nasty. They are part of me and just as important as my brain, teeth, voice, and armpits.

During my period of celibacy, I became comfortable with my sexuality. I discovered what I needed sexually. It was beautiful to control the pace of information. Most of my past lovers never asked what I needed sexually. I was still seeking clarity. I even considered going to a sexologist.

While my healing journey was progressing, I reconnected with my childhood friend Julie and we were having girl-talk.

We gossiped about my lack of a lover and my challenges with sexual intimacy. She gently encouraged me to get back in the game of exploring and touching my body to figure out what I liked and disliked. "The body" component of the body, mind, spirit, and heart of my healing journey continued from my scarred legs, to my face, to the study of my erogenous zones.

As I continued my healing journey, therapy, exploring meditation, and yoga, I began to feel more and more relaxed and less anxious about dating. So, I decided to continue my adventures in online dating. Within two weeks of returning to the dating site, I got an intriguing message. From his self-expressions, questions, and photos, I could tell he was a *seasoned somebody*. That is, a man much older than I was, who had experienced life, and a man who understood the art of courtship. Let's call him Mr. G. I trusted my decision to respond to his message. Gradually, we got to know each other online and eventually offline.

This was a proper man. This was a cultured man. Mr. G. could discuss anything about his life, including his fears and insecurities. His transparency and ease of communication was like nothing I had experienced in any relationship, platonic or otherwise. I was trusting my intuition and my decisions. So, I let him into my world. Trust was easily fostered. We shared similar values and interests. He was not perfect. Nor was I. Mr. G. demanded proper communication and emotional intimacy. He would ask me questions, not out of boredom or entertainment, but to understand my why.

In this new relationship, I still did not know what I needed sexually. Mr. G. helped me with that equation. I had my first

orgasm with a man in my forties. He was the first man who made me feel completely safe in body, mind, and spirit. We connected spiritually. I could be my most authentic self when I was with him.

Outside and inside the bedroom, Mr. G. taught me the skill of communication. The listening part, in particular. He taught me the caring that love requires. With intercourse, grocery shopping, or deciding what to do on vacation, the questions he asked were the same: *Tell me what you need, Wen. Show me what you need.* I had met an emotionally mature man. He paid attention to my responses. He was listening.

Our minds are like sponges. They take on the shape of whatever we feed them. Our minds turn around and birth the thoughts, emotions, expressions, behaviors, and decisions we support. Through painful self-work, I nourished my mind with love, one tablespoon at a time for over fifteen years. My healing journey does not end, for I still have breath.

With all the battles I had been fighting since New York, I knew and intuitively felt that I could calm the chaos inside my mind. That's when I made the promise to myself. Over fifteen years ago, I promised myself that I would live a joyful, peaceful existence. I knew it wouldn't be candy canes and rainbows every day, but I was going to commit to the work as if my life depended on it. I promised myself that I would turn pain into purpose. I promised myself I would transform shame into celebration. None of this would have happened without the blues and the oranges. Inner child healing heals the child within you, and in that journey, you create a new you.

I was "self-love in bloom." I was able to be my most authentic self. For the first time, as an adult, I was wearing shorts! I wore short skirts and short dresses. I was comfortable wearing bathing suits on the beach. I wasn't covering up my scars with body makeup or wearing stockings in ninety-degree weather. As I built that emotional bond with myself, it elevated my self-love and self-worth. I asked for what I needed. I was specific about these needs. I unlatched myself from the trauma bonds that were my slave master. It was so freeing to be in this new place. I had stepped into the promise I made to myself fifteen years ago.

Yes! We must honor how we feel. We should not suppress or deny those feelings. To do so, according to me and my experiences, would be self-abusing. We must grieve for the child within ourselves. We must accept all the parts of ourselves. The good, the bad, and the horrible have equally shaped and informed our becoming. We must not wallow in the low days. Get up! Cry out loud! Put on that Tina Turner song and sing "rollin down dah rieeeverrrr." Dance! Sit in nature. Feel that warm sun. Love! Laugh at yourself! Tap into what made you spring to life when you were a child. Dream that "too big" dream!

When you train your brain, you develop a surge of mental stamina that will augment your entire way of life. You become the Wayne Gretzky or Flo-Jo of self-discipline. You won't be practicing hockey or running track, but you will be practicing self-love. You will gain confidence to speak up for yourself when no one else does. You will become empowered. Every tiny step matters. As you continue to heal, tell your future self, *hold that seat at my table*

of inner peace, for I will be there! You can heal your wounds. You can create a new version of yourself. The discipline of doing the work, of healing, will be the birthplace of the new you!

Healing is not sexy. It's not a Beyonce concert. Healing is not a one-and-done event, like the Superbowl. It is not a glitzy, fun, watch-from-the-sidelines kind of gig. Healing is the tiny incremental steps, the training, the everyday things we do to become the quarterback of our own lives. Take breathing, for example. That one, long, deep, two-finger-snaps-breath I take when I begin to feel overwhelmed, turns into three, five, eight breaths that eject the devious, negative self-talk. That slow-down-and-mellow skill of breathing kicked off my healing journey and remains my go-to technique for calming my mind.

Without a doubt, my abusers owned my first twenty-eight years. Now, as a result of my suffering and my healing journeys, I have earned the gift of choice: heal or remain in bondage, feeding my abusers' egos, their proud glory of manipulating and reducing me to zero. *I controlled my next move.*

Like Eckhart Tolle says, "what is, cannot be otherwise." I was abused. Fact. Do I regret being abused? Do I regret having abusive parents? No. I had no choice in the matter. My will was taken. Where there is no choice there can be no regret. The past cannot be undone. I accept I was sexually and physically abused. I have already spent twenty-eight living years wading through dead episodes, giving them life. I am ready to live fully in the present tense.

Now I have the freedom of choice that Grannie Yaya never had. I choose to heal. Healing *must be* part of my remaining

living years. Looking across my life and into my senior years, what will I regret more than anything else? Would I regret not choosing to heal little Wen, my childhood trauma? Would I willingly break my whole heart just like my parents did to me? NOT HAPPENING!!

I choose to become and live the example of the life I need. Diligently, I will work night and day to build the stamina of self-love. I will become freedom.

Make room for me, freedom!

Do you hear me? I am going to multiply you into every one of my dreams!

About five years after the Virginia awakening and fifteen years after *that* Oprah show, I held a ceremony for my past. It took place in Lake Norman Park in North Carolina. The park bore the name of the terrorist who sexually abused me, my father.

Reaching for the photograph in my back pocket, I saw her. My knees sighed into the carpet of pine. There she was. Waiting. In her red tank top and black shorts with socks pulled to her knees, her smile still dwarfed the sun. Gently, I put down the photograph. With little Wen nestling in a cradle of grass, twigs, and leaves, I whispered to her:

Dearest Little Wen,

You have been my oldest friend, often my only one. You have been so busy, taking care of me, carrying my shame and self-hate inside your small heart. I was scattered in a grown-up wilderness without a map to my home. I am so

sorry for trying to make you be the parents I never had. I beg your forgiveness.

I did not know I was hurting you and neglecting your true needs. I did not know how to fully trust the flickers you sent me. I do love you so. More than anyone in the world and definitely more than Haagen Dazs strawberry ice cream.

Please forgive me for blaming you for my suffering. You are tired, I know. Tired of taking care of both of us. It's time now to celebrate your generosity. Help me let you do that. You have been waiting so long to live your dreams. It is time to do that now. Unlace your little fingers from mine. It's okay, for you are safe now. You can trust me. No one can hurt you any longer.

My beloved, let go of my hand. You can do it. Go on. Play with life! Hop-scotch with Julie and Deidrea. Scurry after that sand crab. Tickle the sole of your baby brother's feet until you are the color of sugar apples. Sing a laugh when granny tries to dance like Tina Turner. And share. Share your story. Share your wide-brimmed smile, springing hope forward into another child's heart. My curious little darling, let go. Go surf your dreams!

Among a sky of forgiveness and a congregation of hope, I opened my spirit and was baptized by freedom's breath.

Journey to Self:

In your healing journey, when you become emotionally mature, you can check in with yourself and recalibrate your thoughts. You will start to adjust your thinking before taking actions that you most likely will regret. In doing so, you get the opportunity to listen to yourself and your inner voice. We listen to others in order to learn and understand their points of view.

When you become overwhelmed with frustration, hurt, anger, fear, and disappointment, and before you react, call upon your future self and ask:

1. Whose thoughts are these in my head? Are they mine?
2. Whose voice am I hearing in those emotions that I am feeling?
3. If I were to do what that voice in my head says to do:
 a. How will I feel an hour from now?
 b. How will I feel in a week?
 c. How will I feel a month from now?
 d. How will I feel a year from now?
 e. How will I feel in five years?

When you take a moment to ask yourself these questions, you "air out your thoughts." You can take a few deep, quiet breaths to relieve any anxiety or negative thoughts (whisper warriors). You calm your mind. You create space between your thoughts and your feelings. You then allow breathing room between your emotions and your actions. Recently, I had to do this exercise

with my partner. I also did this with my work colleague. By "airing out your thoughts," you listen attentively to the other person, instead of merely "hearing" them so that you can quickly get a chance to speak.

What I have learned:

1. It is not your fault you were abused, neglected, or traumatized.
2. You are unique, beautiful, gifted, and necessary.
3. The world needs your compassion and your fight to help yourself and your sisters and brothers in hope and healing.

Habits that Help my Healing Journey:

Pour out the pain and sadness; journal, cry, laugh, jump, go for a fast-paced walk, exercise, dance, sing. Find a safe way to pour out the hurt.

Suppressing your feelings multiplies the pain.

Soothe yourself in a healthy way whenever you need to. This is a form of loving yourself.

Find a physical space where you feel safe. It should be quiet and free of distractions. Take a few deep, slow breaths. With

your hand to your heart or gently rubbing your arms, lovingly say the following:

I accept what I am feeling in this moment. I am where I need to be in my healing journey. I feel safe. I have come so far! Bravo to me!!

I will remember to forgive myself and to give my body, mind, spirit, and heart grace and mercy. I deserve this kindness. It's time to love me and my flaws. I love me.

HEALING JOURNAL:
FROM **DEVASTATED** TO **DIVINE**

Companion Journal to the book

INNER CHILD HEALING:
HEAL YOUR WOUNDS
TRAIN YOUR MIND
CREATE A NEW YOU

ABOUT THE AUTHOR

WEN PEETES is a coach, mentor and speaker who helps driven women to finally come home to peace with themselves and the freedom to live life on their own terms. With her popular Instagram @rebelforaspell, Wen continues to expand her reach through her daily content and by sharing tools of transformation with tailored offerings including, her private 1-on-1 coaching program (Born Divinely Worthy), her VIP Retreat and her group mentorship program (Self-Divine Healing Accelerator). Wen is also a songwriter, singer and a producer, releasing the album Woman Empowered under her moniker Wendy St. Kitts and singles under Violins For Milk.

As a survivor of childhood trauma and abuse, Wen found herself trying to break free from the negative cycle that left her feeling stuck, helpless, and hopeless. Through a series of life-changing events, she found the courage to embrace her darkest secret and the resilience to turn pain into purpose.

In this self-reflective book, Wen gently encourages you to address past childhood trauma wounds and adverse experiences that may cause you to doubt your worth. You may recognize the lasting impact of negative experiences on your relationships with others and yourself. You, too, can become the co-creator of the life you never want to run away from, by becoming the fullest expression of yourself: feeling whole, confident, and peacefully free to live a vibrant authentic life. For more information, visit www.rebelforaspell.com